HOW TO DRAW
CHILLER MONSTERS, WEREWOLVES, VAMPIRES, AND ZOMBIES

HOW TO DRAW CHILLER MONSTERS, WEREWOLVES, VAMPIRES, AND ZOMBIES

J. David Spurlock

Foreword by Rob Zombie

Watson-Guptill Publications / New York

Published 2011 by Watson-Guptill Publications,
an imprint of Crown Publishing, a division of Random House Inc., New York.
www.crownpublishing.com
www.watsonguptill.com

WATSON-GUPTILL is a registered trademark and the WG and Horse designs are trademarks
of Random House, Inc.

Library of Congress Cataloging-in-Publication Data

Spurlock, J. David.
 How to draw chiller monsters, vampires, werewolves, and zombies / J. David Spurlock.
 p. cm.
 Includes index.
 ISBN 978-0-8230-9532-2
 1. Monsters in art. 2. Animals, Mythical, in art. 3. Drawing--Technique. I. Title.
 NC825.M6S68 2011
 743'.87--dc22

 2010045650

Cover and interior design by Jenny Kraemer
Front cover art by David Hartman

Art Credits. Credits for images not noted either in the caption or on the art:
Neal Adams: pp. 50, 53 (bottom image)
Gene Colan: pp. 27–28, 37, 66 (with Dave Gutierrez), 72, 74–77, 128–129, 132
Jack Davis: pp. 90, 92
Kerry Gammill: pp. 30, 33–34, 82–83, 104–109, 113, 126–127
Basil Gogos: pp. 16 (bottom image), 17, 20, 22, 24 (images at left), 38, 48, 69, 71, 84–96
David Hartman: pp. 21, 54–65, 94
Alex Horley: pp. 11, 13, 80, 98–103
Joe Kubert: pp. 24–25, 31, 35
Jim Steranko: pp. 114–119, 124–125, 134–143
Neil Vokes: pp. 36, 52, 68, 70, 81, 110
Bernie Wrightson: pp. 130, 133
The following art is property of New Comic Co.: pp. 15, 18–19, 26, 32, 41, 43, 45–47, 51,
53 (top image), 73, 78, 91, 93, 120, 123, 131

Printed in China

First printing, 2011

1 2 3 4 5 6 7 8 9 / 19 18 17 16 15 14 13 12 11

DEDICATED TO

ALL MY LOVED ONES AND
ALL THE ARTISTS WHOSE WORK
INSPIRED ME TO DRAW.

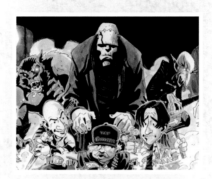

ACKNOWLEDGMENTS

THE AUTHOR THANKS THE FOLLOWING FOR THEIR CONTRIBUTIONS: Rob Zombie, Jim Steranko, David Hartman, Gene Colan, Basil Gogos, Alex Horley, Kerry Gammill, Neil Vokes, Joe Kubert, Pat Binder, Dave Gutierrez, Dan Braun, David Armstrong, Keith Robinson, and Neal Jansons.

Featuring the *Creepy* and *Eerie* art of Frank Frazetta, Al Williamson, Bernie Wrightson, Jack Davis, Wallace (Wally) Wood, Gray Morrow, Steve Ditko, Dan Adkins, Rocco (Rocke) Mastroserio, and Angelo Torres by permission of New Comic Company, LLC.

ABOUT THE AUTHOR

J. DAVID SPURLOCK is a prolific, award-winning author, editor, and illustrator as well as a pop-culture historian and advocate for artists' rights. He served as president of the Society of Illustrators in Dallas and has worked with many of the greatest names in the history of illustration and cartooning, including Neal Adams, Jim Steranko, Julius Schwartz, Basil Gogos, Frank Frazetta, Barron Storey, Joe Kubert, Bill Sienkiewicz, Carmine Infantino, and the Wally Wood Estate. Spurlock's career also includes work for Disney, Sony, Vanguard, DC, Dark Horse, PBS, and MTV. Books by Spurlock include *Wally's World: The Life & Death of Wally Wood*, *RGK: Art of Roy G. Krenkel*, *The Space Cowboy*, *Steranko Art Noir*, *Joe Kubert: Drawing from Life*, and *Paintings of J. Allen St. John*. Spurlock has founded multiple scholarship funds at the School of Visual Arts in New York and has taught at the university level since 1986. *The New York Times*, IPPY Awards, *Entertainment Weekly*, Eisner Awards, National Public Radio, *Time Out New York*, *Library Journal*, the Rondo Awards, *Publishers Weekly*, the Hugo Awards, the *Village Voice*, Locus S-F Awards, and more have acclaimed Spurlock's work. He was a featured guest speaker at the 2010 Famous Monsters of Filmland convention and is co-author of the award-winning book *Famous Monster Movie Art of Basil Gogos*.

Spurlock lives between New York City, Miami, and the grave.

CONTENTS

Foreword by Rob Zombie 8
Preface 10

1 FORM AND STRUCTURE
Spheres, Blocks, Cones, Wedges, and Gravestones 13

Figures 14
Heads 16

2 FIGURE DRAWING
Man vs. Inhuman 23

Life Drawing 24
Drawing from Photographs 26

3 MONSTERS IN YOUR FACE
Perspective and Foreshortening 29

The Figure in Perspective 30

4 LIGHT, SHADOW, TONE, AND TEXTURE
Creating Monstrous Dimension 39

Controlling Light in Your Drawing 40
Spotlight Artist: Frank Frazetta 44

5 ZOMBIES
Drawing the Walking Dead 49

Zombie Origins 51
Spotlight Artist: David Hartman 54

6 VAMPIRES
Drawing the Living Dead 67

Vampires Throughout the Ages 68
Spotlight Artist: Gene Colan 74

7 THE MONSTER
Drawing Dr. Frankenstein's Creation 79

The Frankenstein Story 80
Demonstration: Four Monster Studies 82
Spotlight Artist: Basil Gogos 84
Spotlight Artist: Jack Davis 90

8 WEREWOLVES
Drawing Moonlight Mayhem to Howling Effect 95

A Brief History of Werewolves 96
Spotlight Artist: Alex Horley 98
Spotlight Artist: Kerry Gammill 104
Hollywood Werewolf Drawings by Kerry Gammill 105

9 COMPOSITION
Designing Monstrous Groupings 111

The Components of Composition 112
Spotlight Artist: Jim Steranko 114

10 HARD-LINING IT
The Black of Night in Your Inkwell 121

Tools and Supplies 122
Basic Pen and Brushstrokes 122
Inking Pencil Drawings 123
Spotlight Artist: Bernie Wrightson 130

coda STORYBOARDS
Pre-Direction for Film and TV 135

Steranko's Storyboards for *Bram Stoker's Dracula* 136

Index 144

FOREWORD

I have to admit that the very first thing that popped into my mind when J. David Spurlock asked me to write a foreword for this book, which you are now clutching in your sweaty little hands, was "Where the hell was this book when I was a kid?" How to draw monsters? Geez man, how cool is that? Is there any other information that you really need as a kid to keep you happy as a clam? (I guess clams are happy.) Seriously, this is the exact book that I always dreamed of secretly finding on one of those mind-numbingly dull trips to the school library. Just imagine flipping through the same tired, dusty shelves of boring old crap and stumbling across this epic book. Well, that, my friends, would definitely be a 100-percent life-changing moment for any monster kid. So, perchance if you are that kid at this moment discovering this book in your crummy old school library, I say bravo, punk! Get ready to get your monster freak on! In a nutshell, here is basically everything you ever wanted to know about the fine art of drawing werewolves, vampires, zombies, and even the Frankenstein monster but were afraid to ask. Need some info on the art of inking? Well, no problem, we got that. Composition got you down? Don't fear, we've got your back on that one, too. Form and structure making you crazy? Calm down, it is all explained here. Now, seriously, if that isn't enough for ya, I really don't know what you want—but we've got more! Gathered inside these unholy pages are a very, very select group of monster masters presenting some of their finest creations for you to howl and drool over like Larry Talbot under a harvest moon. *Aaaaaaaaaaaaahhhhhhhhhooooooooooooooooooo!*

I have been very lucky and have had the incredible pleasure of working with many of these amazing artists up close and personal, like Basil Gogos, David Hartman, Gene Colan, and Alex Horley. Others, I've just worshiped since childhood, like the king of all monsters— Frank Frazetta! That guy still rocks my world. At any rate, these cats will clearly illustrate just how far the art of drawing monsters can go. What could be forgettable trash in the wrong hands turns into high art with guys like these on the prowl. They set the bar high, but why not learn from the best? Anyway, what more can I say? This book is a monster lover's dream come true, so let the horror show begin!

—ROB ZOMBIE

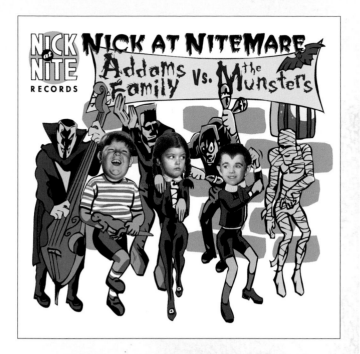

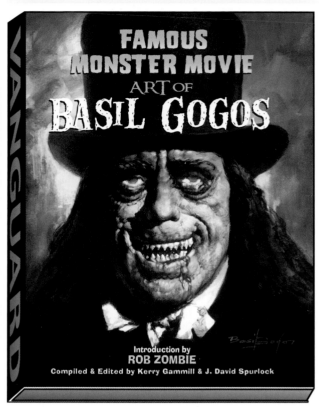

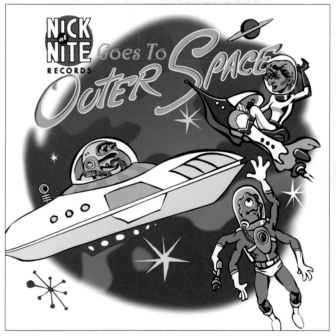

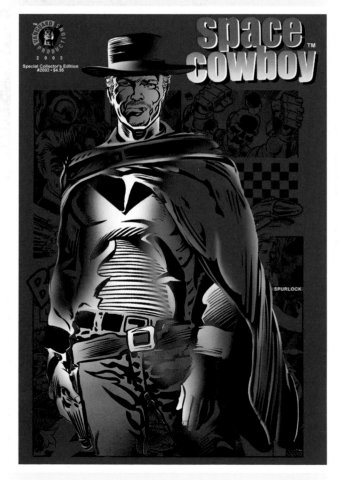

Top left: J. David Spurlock's art for Nick at Nite Records'
CD *Nick at NiteMare*. In the released version, they had me
replace the *Addams Family* and *Munsters* photo heads with
drawings, but I prefer this, the original version.
Top right: The Rondo Award–winning Gogos retrospec-
tive *Famous Monster Movie Art of Basil Gogos* (Vanguard,
2006), by Kerry Gammill and J. David Spurlock.
Bottom left: *Nick at Nite Goes to Outer Space* CD cover art
by J. David Spurlock (Nick at Nite Records, 2007).
Bottom right: My cover for the *Space Cowboy* comic book
annual (2003).

PREFACE

Monsters! *Grrrrrr.* Creatures of the night, diabolical fiends, monstrosities with overwhelming strength . . . ghosts, goblins, mummies, zombies, werewolves, vampires, and those terrific things that go bump in the night. From such hellish spawn, protective charms are eagerly sought, and the people have ever prayed, "Good Lord, deliver us!"

There are those who study these things—the undead, the walking dead, and such. There are those who seek them out to rid the world of them or to attempt to master them. While most humans are terrified and revile these horrors, some pity the things as the world's ultimate outcasts—homeless, friendless things that hate themselves and the world for the misery of their existence. There are even those who have a fondness for these depraved derelicts of destruction and keep them with delight—in their minds or in their homes—sometimes as pets, until they break free to ravage again through the night.

There are likewise those who, for various reasons, need or want to draw such monstrosities. This might be for scientific purposes: field studies of monsters in their acts of mayhem or to illustrate classic texts or to design monsters for movies, television, or comic books . . . or, even just for the diabolical thrill of it! This book is for everyone who has the need or desire to draw or know about drawing the most treacherous creatures of the night.

One of the most important elements of any art instruction program is art appreciation. You can't produce great art, monster art or otherwise, unless you know what great art looks like. In this book, I'll give you some lessons in the basics, and then I'll show you master artworks and explain in detail how the artists executed them. When you understand how the monster art masters did it, you'll be able to apply their vision and techniques to your own work. You'll be amazed at how quickly your art improves.

We'll cover all the basic concepts and techniques—form and structure, figure study, perspective, light, shadow, tone, and texture—and then we'll work on drawing the creepy creatures themselves with chapters dedicated to zombies, vampires, the monster, and werewolves. In the last two chapters, we'll apply everything we've learned to creating dynamic composition and spectacular finished artwork with inking. Throughout the book are special Spotlight Artist sections where contemporary masters share their most memorable works and the stories behind them—Frank Frazetta, grand master of fantastic art; the legendary Jim Steranko on color and composition; Bernie Wrightson, master of the macabre; multitalented David Hartman and his zombies; Gene Colan, Dracula master; Basil Gogos, Frankenstein genius; Jack Davis, the original master of bigfoot horror; step-by-step werewolf drawing from the visionary Alex Horley; and werewolf commentary from the innovative Kerry Gammill. In an exclusive, special bonus, Steranko shares a complete scene from the storyboards he created for Francis Ford Coppola's *Bram Stoker's Dracula.*

Are you ready? As the great king of the vampires, Dracula himself, said, "ENTER FREELY AND OF YOUR OWN FREE WILL!"

A trio of monsters by fan-favorite *World of Warcraft* game artist Alex Horley.

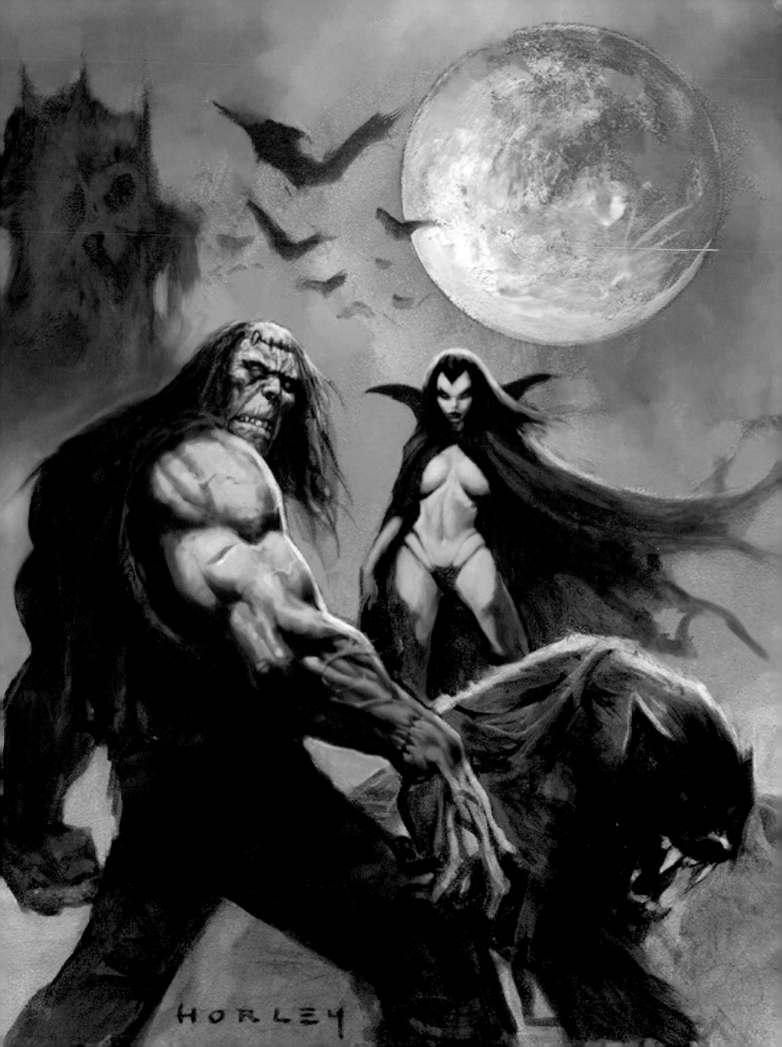

HORLEY

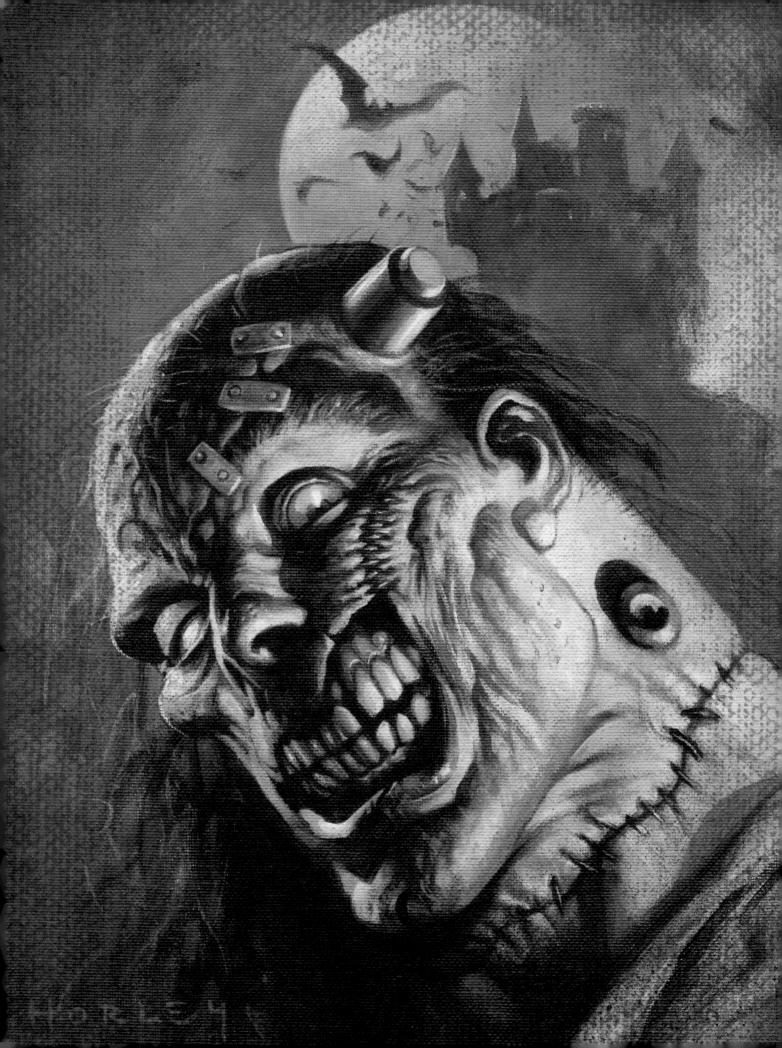

FORM AND STRUCTURE
Spheres, Blocks, Cones, Wedges, and Gravestones

The werewolf came across the hill,
—Eerily, wind, sing eerily—
The vampire drank at the Devil's still,
And the wind was blowing eerily.
Eerily, eerily, blow, wind, blow,
With a heave and a hey, so eerily.

—ROBERT E. HOWARD
"Weird Ballad," 1932

Whether drawing down the moon or drawing out blood or drawing zombies out into the open, if you want to draw with pencil and paper, you must develop a basic grasp and understanding of structure. The easiest way is to envision in your mind the object or monster of your desire in simplified shapes: spheres, blocks, cones, wedges . . . even gravestones!

Think of these shapes as the components of the basic body structure for figures in any pose, as well as the structures for heads, faces, hands, and feet. By studying the underlying forms in both life and master artworks and applying them to your own work, your drawings will look more realistic and better tell their story.

The basic block-like structure of this Frankenstein monster's head is clearly evident in this classically painted piece by famed fantasy artist Alex Horley.

FIGURES

Whether you are working with or without visual references—like models, photographs, skeletons, and cadavers—it will help to keep in mind the following recommended figure drawing proportions for a standing model. (Figures that are affected by extreme perspective and foreshortening will differ; see chapter 3 for more details.)

- An average human is generally seven and a half heads tall.

- To idealize or add nobility to a subject, you can draw the figure eight heads tall.

- Heroic figures (mythological heroes, superheroes, gods) are eight and a half heads tall, with much of the additional length being in the legs and chest.

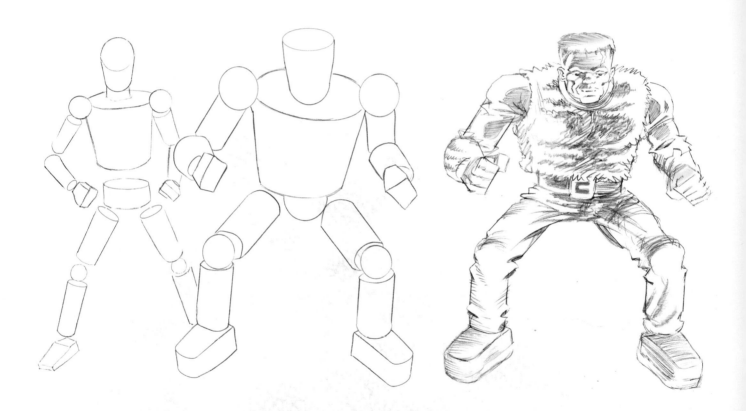

You can see how I have taken these basic shapes—sphere, wedge, cylinder, and gravestone—in their simplest outlines and used them to piece together rudimentary mannequin-like figures of a man and a monster (thank you, Dr. Frankenstein).

In this approach, we loosely construct the body out of the following shapes: Spheres (or egg shapes) are often used for the cranium and the joints; cylinders for the thigh and calf, forearm, upper arm, and even the torso; a wedge is best for the hands and feet; and small cylinders for fingers and toes. Once assembled into the basic body structure, we trim and refine these shapes to more closely represent the final form—whether human or inhuman.

It's easy to see the basic-forms structure of the monster that underlies this more rendered-out pencil drawing. Particular to many versions of the Frankenstein monster is a flat head and tombstone-shaped shoes. So in this monster, the head is more of a cylinder than the standard sphere or egg shape.

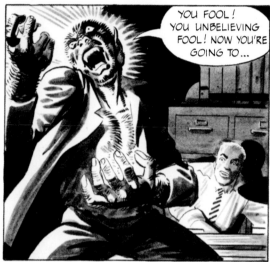

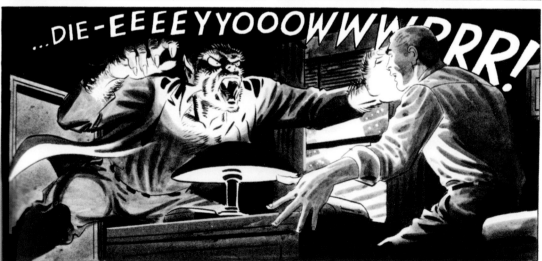

Here is a stunning example of atmospheric Steve Ditko art, drenched in shadows and beautifully rendered in tonal ink wash. The simplicity of Ditko's forms makes his work superb examples of the use of basic shapes as building blocks for figures. The underlying forms enhance his evocative lighting, which adds to the overall dramatic impact of the piece.

HEADS

Our focus on form and structure is equally important when focusing on each element within the figure. There is no more important element than the head. As mentioned, human heads tend to be based on a sphere or egg shape, but monster heads can vary widely. On the following pages, the art reflects widely varying styles, yet all the artists know how to communicate form and structure intimately.

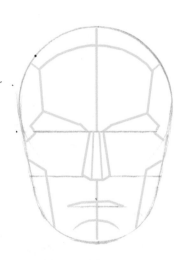

Here are the classic proportions for the features on a face. Note that the eyes are near the midpoint of the face and that the ears are between the levels of the eyes and nose.

As with the figure, you can see that I've taken the basic shapes in their simplest outlines and pieced them together into a generic face. Once assembled into the basic face structure, we trim and refine the shapes to more clearly represent the final face.

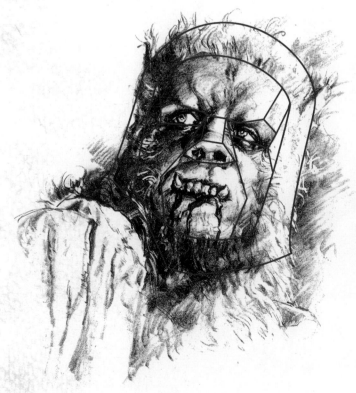

There are layers of forms in this fabulous Basil Gogos werewolf charcoal. Cylinders provide the basic structure of the shoulder and head, while blocks and cones form the features of the face.

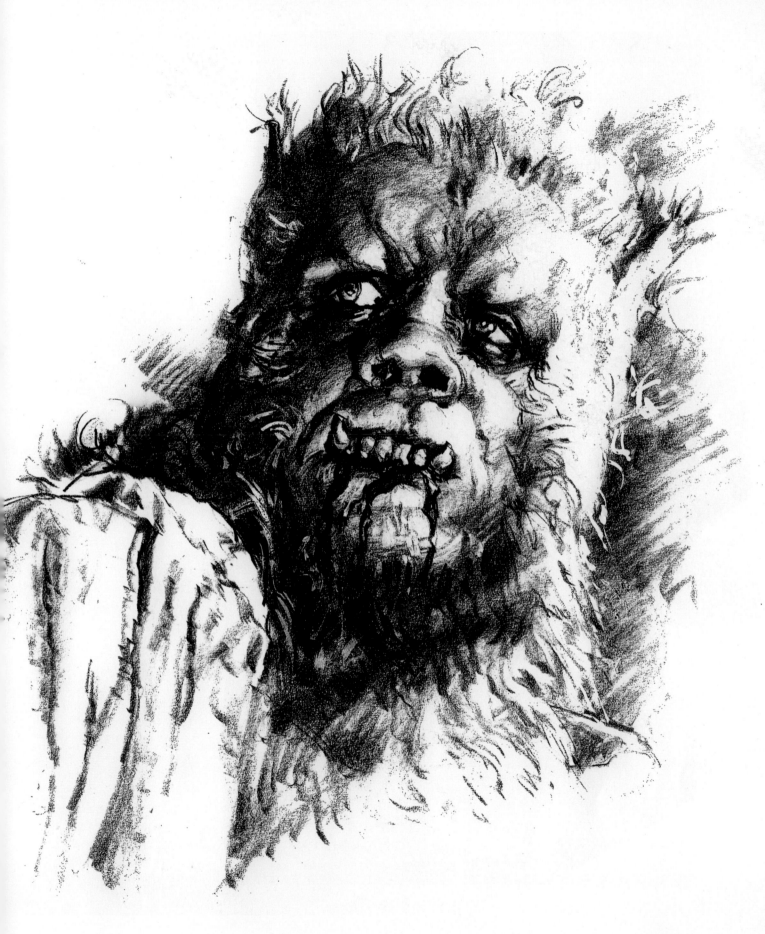

In contrast to Gogos's realistic but stylized commercial illustration techniques, *Spider-Man* and *Dr. Strange* co-creator Steve Ditko seems to revel in the art of simplification. Ditko tends to focus on storytelling, which, as in filmmaking, is the higher art in comic book work. Like the work of Alex Toth and later Wally Wood, Ditko's figures are interesting (and in Ditko's case, quirky) exercises in the beauty of simplification and of distilling the figures to their essence as it serves the story. That being said, Ditko, on occasion—such as for black-and-white horror magazines—surprises his audience with beautifully rendered and sometimes fantastically detailed works.

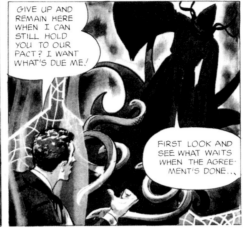

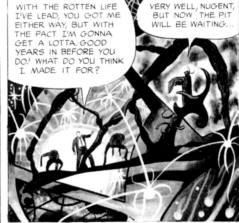

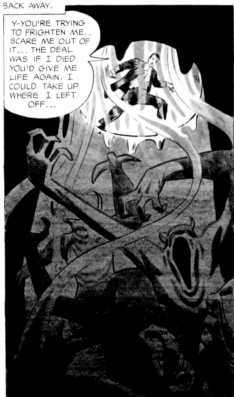

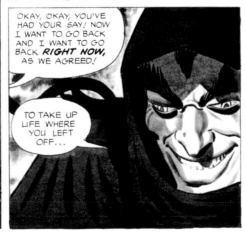

This panel is from the story "Second Chance" (*Creepy* #13). Ditko imbues it with so much mystery and character through the lighting and design, but at the core of it all are the forms, planes, and structure of the face.

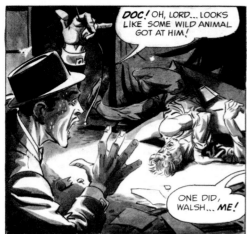
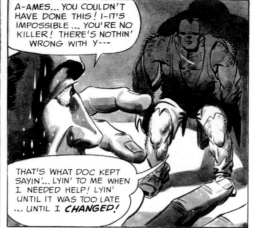
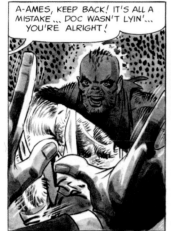
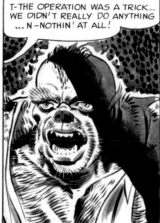
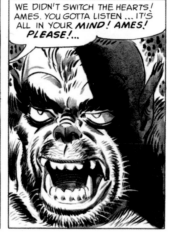
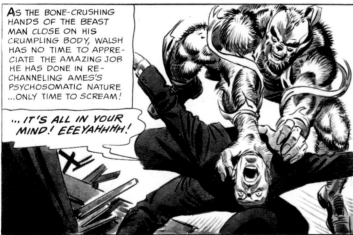
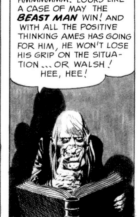

Above is a Ditko sequence from the story "Beastman" (*Creepy* #11). Note Ditko's use of dramatic lighting, hairy texture, and more to great effect. The sequence allows him to move the subject progressively and menacingly closer, the subject appearing more beastly in each frame. The potently textured background indicates the nervous state of the victim and ratchets up the tension, while the victim's hands in the first panel add spatial reference and help move the scene forward. Ditko caps the sequence with a particularly (and delightfully) beastly and maniacal expression on the creature's face.

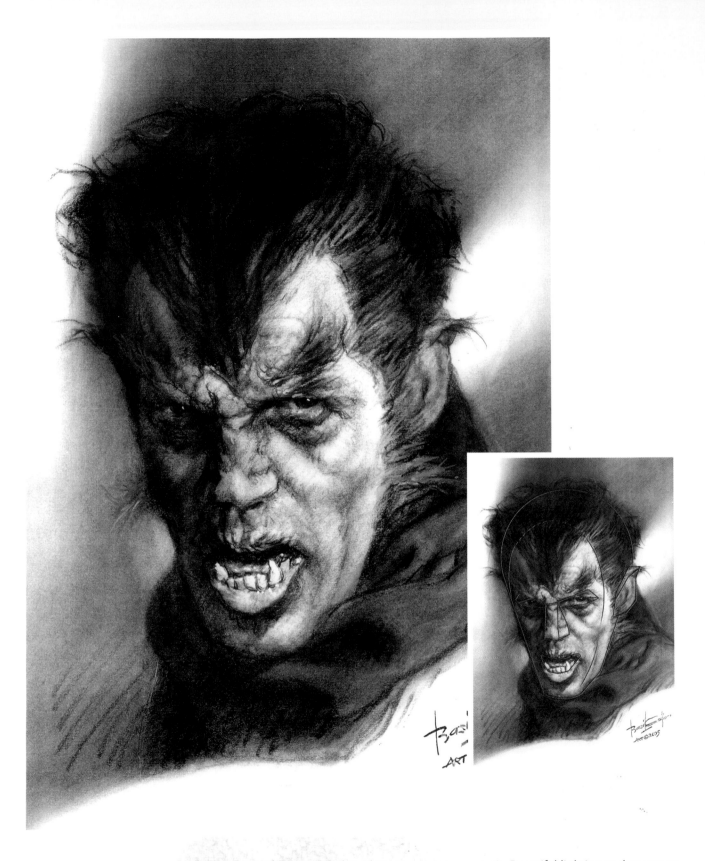

Another masterfully rendered Basil Gogos monster portrait. Beautiful lighting and great yet subtle contrast of tones and textures are featured throughout. But it is also easy to see the underlying structures of the nose, chin, head, mouth, and other features.

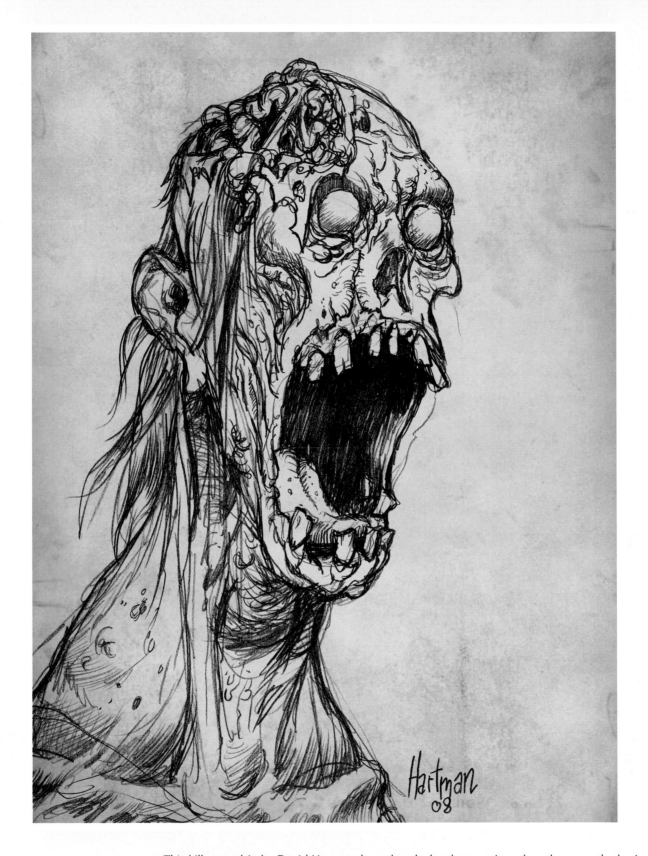

This killer zombie by David Hartman has a headache that won't end, and you surely don't want to get in his way. Artists study muscle and bone structure to know what goes on under the skin, to add better believability to their drawings of humans. With a zombie like this, the muscle and bone—and some brain matter—actually are the final subject. It is easy to see how form and structure play into this drawing.

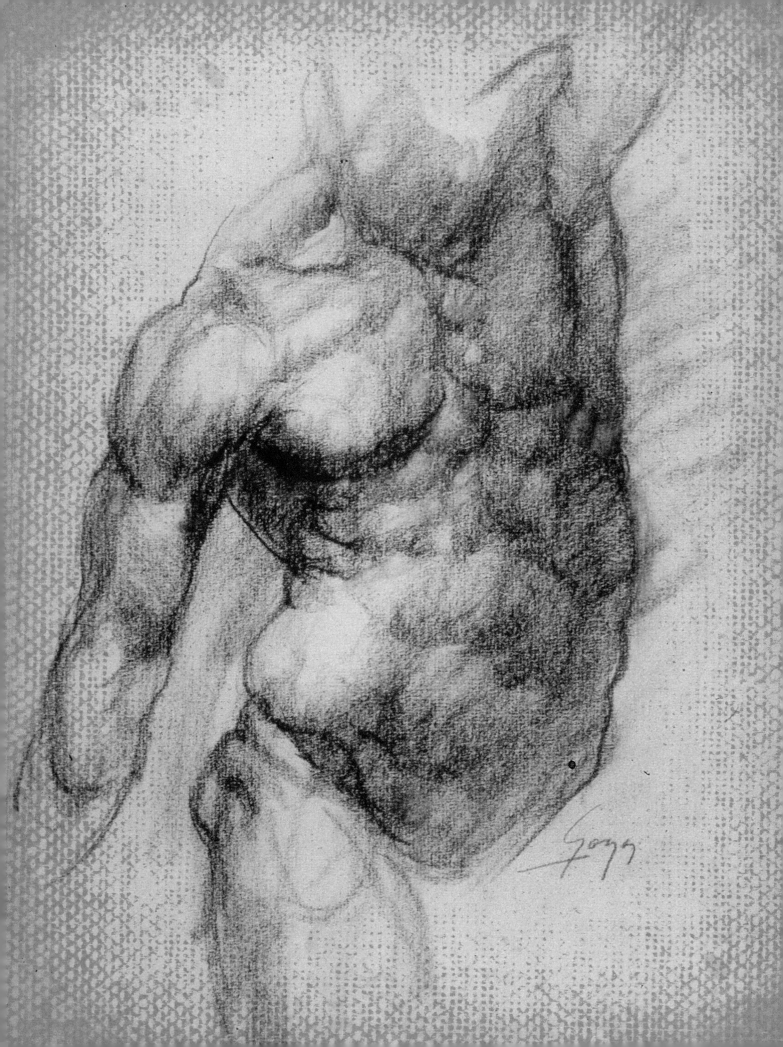

FIGURE DRAWING
Man vs. Inhuman

Earth below is lost in darkness,
Waves like mountains strike the sky,
Whilst the lurid lightning flashes,
And lost spirits shriek and cry.

Ne'er on earth was such dread darkness,
Ne'er such horrors, ghostly forms;
Ne'er such strokes of sulphurous lightning,
Ne'er such hellish terror storms.

And their aspect seemed unnatural,
Devilish was their face and form;
Peals of shrieking, ghostly laughter
Quick increased, as did the storm.

—ROBERT BENJAMIN
"Hades," 1890

There is a trap that waits for all who would draw monsters—and believe me, the zombies, vampires, and werewolves (among others) want you to fall into this trap. The trap is that it seems easier to draw monsters than other things—easier to draw monsters than men or women or children or horses or sleek sports cars. But it is just a trick; a trick for the weak, so that when the time comes, when you are there and have the walking dead in your sight, you will be ill prepared to capture its nauseating visage in any meaningful way.

The only way to *not* fall victim to this monstrous trap is to force yourself to draw not only monsters but men, women, children, horses, and, yes, maybe even the occasional sleek sports car. By drawing these reality-based subjects, you gain greater understanding and control. With this reality-based preparation, your monster drawings are not just drawings based on your imagination but are based on a good understanding of human and animal anatomy and structure. This way, when you find yourself in the field, studying zombies, vampires, werewolves, etc., you will be able to most accurately capture their likenesses, which, assuming you make it home alive, will likely help save the lives of other humans.

This human life study by Basil Gogos was done with soft media—like charcoal or Conté crayon. You can see structure in the musculature and a touch of reflective light on the spine muscles.

LIFE DRAWING

When drawing the human figure—or inhuman—it is helpful to draw not just from imagination but also from various types of reference material, including memory, skeletons, statues, live models, cadavers, mannequins, and photographs. To perfect their representation of human anatomy, proportion, and musculature, artists throughout the centuries have studied and drawn from classical Greek and Roman sculpture. Classic art instruction focuses on this practice of drawing from statues and the use of models in "life drawing" sessions.

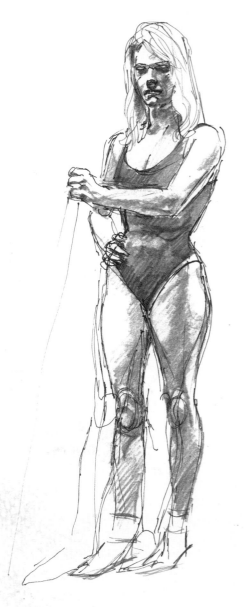

These life drawings are by the Master of Monsters, Basil Gogos. Gogos is so experienced that he doesn't need to, but many people start life drawings with directional lines for the spine, shoulder, and pelvis.

This human life drawing was done by legendary comic book artist Joe Kubert. Life drawings uniquely show work in progress. Here, you can see how Kubert made updates to the subject's legs to correct the stance.

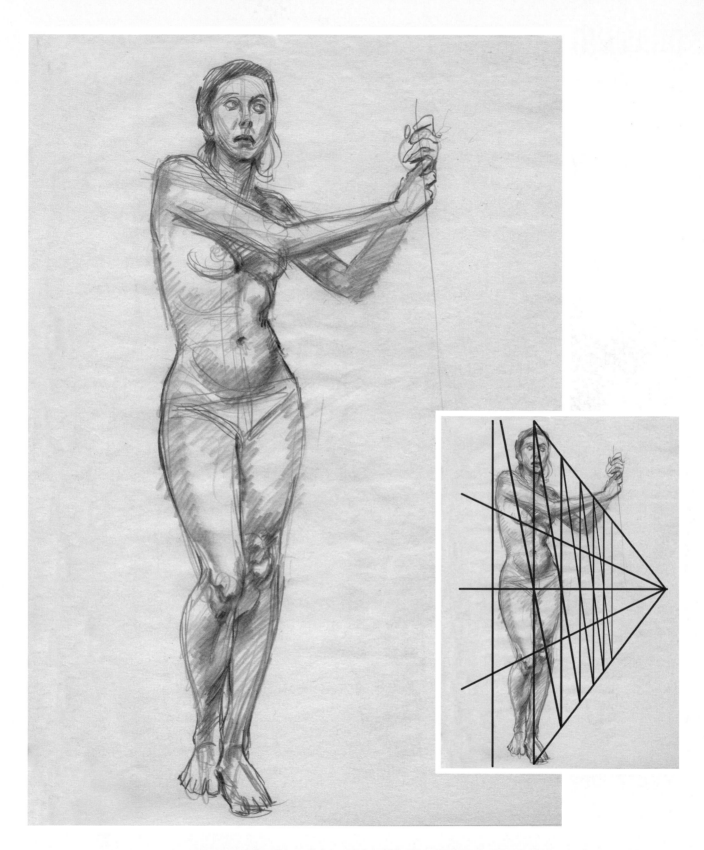

Here is another beautiful Joe Kubert life drawing. Anatomy, proportions, lighting (always keep your light sources consistent), weight, and flexed muscle versus relaxed play a major role in figure drawing. This remains true whether you are drawing human or inhuman. The lines here give an indication of how perspective affects this figure.

DRAWING FROM PHOTOGRAPHS

Photo reference is used sparingly in fine art but is regularly used by illustrators. When using photo reference, be careful to not produce "flat" images. Photography is flat or two-dimensional, as is your drawing, and it is important to imbue that work with three-dimensional qualities. While drawing from imagination affords lots of room to be expressive, it begs for inevitable inaccuracies stemming from the artist's limited memory of the subject and/or lack of knowledge.

As an exercise, it can be advantageous to try an anatomical approach when drawing from photo reference. Begin by sketching the skeleton of the figure, followed by the internal organs and muscles, and then cover those shapes with the skin and clothing (if any). With this technique, you are following, a bit, in Dr. Frankenstein's tradition: As Dr. Frankenstein understood, the study of human internal anatomy is required for this technique. Finish up by focusing on the shapes created by the interplay of tonal values of both darkness and light on the surfaces of the body and on the communication of various textures (rotting flesh, tufts of fur, veins, and more; see page 42), as these are the icing on the cake . . . so to speak.

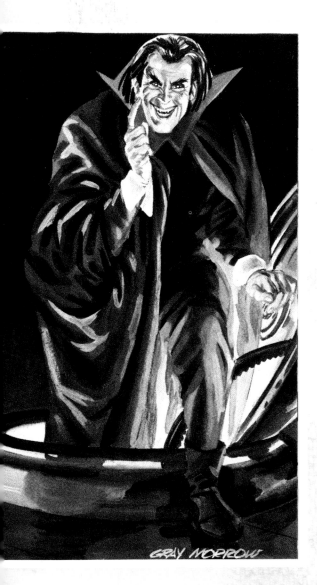

This ink wash of a vampire in a space ship is from "Blood of Krylon" from *Creepy #7* (Warren, 1966), illustrated by our good friend Gray Morrow. (The title is an inside joke for artists, as Krylon is a popular brand of spray fixative, which is used to protect artwork.) Morrow worked in animation (the original *Spider-Man* cartoon), as a newspaper strip artist (*Tarzan* and *Buck Rodgers*, among others), as a book-cover illustrator (the *Perry Rhodan* series, for one), and as a comic book artist (*Creepy*, *Man-Thing*, *Star Trek*, and many others). While Morrow, like most other comic book artists, could create scenes from his mind alone, he preferred very realistic work and often used photo references to that end.

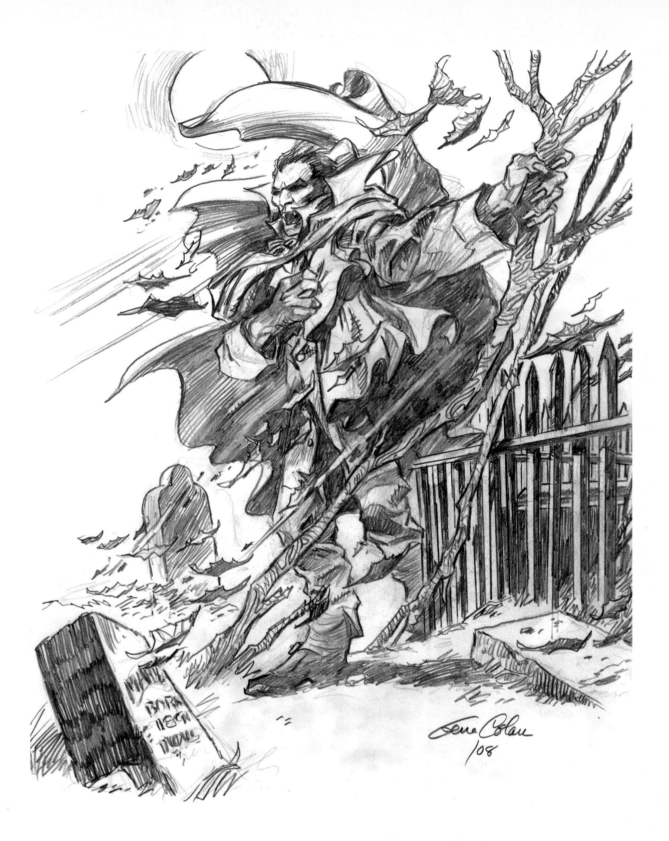

This Dracula piece is by artist "Gentleman" Gene Colan, who frequently uses photo references in his work, too. But Gene is unique because he generally uses photo references just for heads and faces. He creates his figures out of his imagination—often exaggerating anatomy to boost action and for effect—but he adds great believability to his drawings by using photo references to render detailed faces and facial expressions.

CHAPTER 3

MONSTERS IN YOUR FACE
Perspective and Foreshortening

Darkest clouds of blackest Hades,
Whirling onward into space;
Full of forms of ghostly horrors,
Madly join the phantom chase.

Earth below is lost in darkness,
Waves like mountains strike the sky,
Whilst the lurid lightning flashes,
And lost spirits shriek and cry.

—ROBERT BENJAMIN
"Hades," 1890

Perspective as it relates to drawing is a representation, on a flat surface (paper or otherwise), of a figure or object as it is perceived by the eye. The characteristic feature of perspective is that objects are drawn smaller as their distance from the observer increases. Additional perspective can be conveyed by the use of foreshortening, the visual effect or illusion that an object (like an arm or a leg) appears shorter than it actually is because it is angled toward the viewer.

Foreshortening and perspective give your drawings a quality of dimensionality. You want the viewer to feel like he or she is actually in front of the subject—zombie, vampire, or otherwise. The foreshortening and perspective pulls the viewer into the scene.

This drawing by Gene Colan is from his Spider graphic novel (with writer Don McGregor) entitled *Scavengers of the Slaughtered Sacrifices* (Vanguard, 2002). © Argosy Communications 2002. Used by permission.

THE FIGURE IN PERSPECTIVE

Many good art books discuss perspective, but very few discuss the figure in perspective. Reclining poses provide some of the best examples of perspective and its effect on the figure.

It isn't enough to know a human figure is seven heads tall standing perfectly straight. You have to familiarize yourself with, and be able to communicate, how a claw looks coming at you, about to rip out your jugular vein, or how the snout of a werewolf looks bigger when it is in your face, breathing the worst smell of brimstone and rotting flesh you wish you never had to experience except through your drawings.

When you have to draw the figure without a model or photo reference, begin your figures with the cubes, spheres, cones, wedges, and gravestones discussed in chapter 1. There are some artists who can visualize the scene on the paper and, in effect, trace the visualized figure. Even if you are one of the lucky few who can visualize perspective and transfer it to paper, or you are drawing from a detailed reference photo, your drawing can sometimes just not look right. Most likely, this is because your perspective is off. This is why drawing from life is so important; it will train your mind to translate and your hand to accurately render the proportions in two dimensions that the eye sees in three dimensions.

This is a creature design by Kerry Gammill. He calls it Flukeman and originally drew it while coming up with ideas for the *X-Files* TV series. There are various places that perspective plays into this drawing, including in the descending layers of the mouth. The forearm lifted up in front of the torso adds dimension and produces some foreshortening, which is most noticeable on the arm between the shoulder and the elbow. The same holds true for the rear arm as well. Kerry chose to give this creature particularly large hands, which creates an almost subconscious illusion of extreme foreshortening, with the ultimate effect being that his hands seem ever threatening . . . ever coming for you. The wisp of mist overlapping the leg adds dimension still, adding to the effect that the upper body is lurching toward us in a threatening manner.

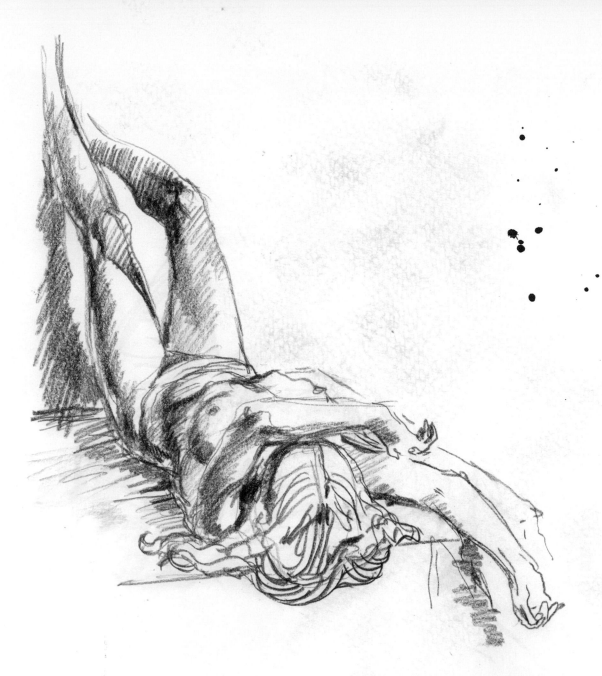

This reclining nude by Joe Kubert is a good example of the use of perspective in the figure. Perspective and foreshortening go hand in hand (or claw in claw), which might be even more evident in figurative (and *monsterative*) art than in nonfigurative art like landscapes and still life. The deeper the perspective, the more foreshortening comes into play. In this drawing, we see the subject's right arm extended toward us, then the head, then the left arm, which overlaps the torso. Continuing, progressively back in perspective, are the breast, rib cage, belly, pelvis, and the legs. You can see how it is all tapering as the subject gets farther from our view. The shadows and overlapping elements add significantly to the communication of form and 3-D qualities.

In communicating and rendering with perspective in mind, be aware of the pertinent vanishing points. Looking at this figure, imagine lines drawn from the shoulders to the hips. Continue the lines to the horizon. (The horizon is where, in your line of view, the earth seems to meet the sky.) In this drawing, if your perspective is correct, the line from the left shoulder to hip to horizon will meet the line from the right shoulder to hip to horizon at the horizon. That point is referred to as the *vanishing point*. Not all vanishing points are on the horizon, but more are than aren't. An example of non-horizon vanishing points would be something like this: If you were staring upward at a very tall skyscraper, the upward (vertical) vanishing points on that building would meet somewhere out in space, while the horizontal vanishing points for the same building would tend to go toward the horizon.

Here is a drawing by *Spider-Man* co-creator Steve Ditko. Ditko's eclectic style brought an eerie, spidery quality to the early *Spider-Man* stories, which *Spawn* creator Todd McFarlane and others revived years later. Ditko's work is particularly suited for horror and mystery subjects, and he has done a lot of it, but the tonal ink-wash drawings he did for *Creepy* and *Eerie* magazines afforded him unique opportunities to exercise his mysterious prowess.

We see Ditko rendering an engaging dark character. He adds depth and dimension to his work by building a series of spatial levels: the background wall; the shadow cast by the subject on the wall; the head, farther away and thus smaller than the hands; and, closest to the viewer, the hands, which are twice as large as the head. Ditko adds further dimension by drawing the seemingly double-jointed fingers so they pop forward toward us in a bit of a 3-D effect. In drawing the hands bigger and the head smaller, Ditko is incorporating foreshortening in his successful attempt to add dimension to the drawing and pull the viewer into the scene.

This Gene Colan drawing is from *Eerie* #7 (Warren, 1967). Here Colan uses perspective and foreshortening as a storytelling tool to add dimension and pull the viewer's interest into the scene. Take note of the overlapping elements. The victim's hand is closest to us and therefore drawn the largest. As elements move away from the viewer, they are drawn progressively smaller—the monster's hand is larger than the victim's head, followed by the smaller monster's head and an even smaller monster head behind it. Farthest from the viewer, and therefore proportionately the smallest elements of the drawing, are the banister and woman witnessing the nightmarish scene, with a dramatically lit wall behind her. There are at least eight levels of depth in this drawing, all of which, via the use of perspective, are descending in scale. Colan's unusually shaped panel adds to the effect.

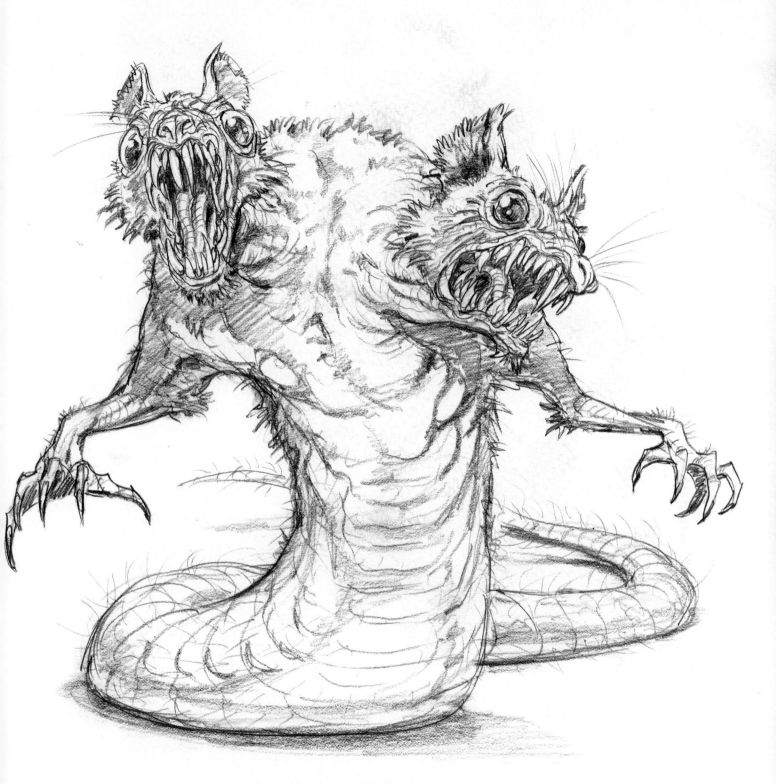

Above is one of Kerry Gammill's film-creature designs. It was presented for a proposed Tim Burton Superman film, tentatively titled *Superman Lives*, which would have dealt with the death and return of Superman.

Somewhat like Siamese twin rats with a hairy, snakelike lower body, the figure incorporates perspective in the heads jutting toward us, in the foreshortened claws, and especially in the diminishment of the tail as it is drawn progressively smaller as it trails behind the upper body.

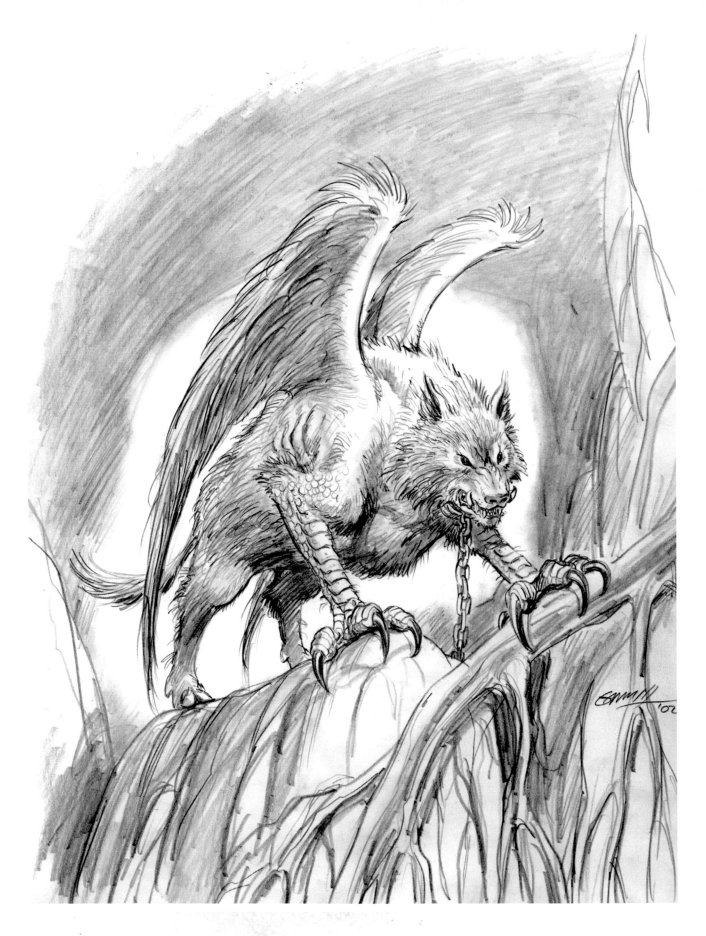

MONSTERS IN YOUR FACE

This Kerry Gammill creature design (opposite) was for a Three Musketeers TV show called *Young Blades*, which ran in 2005 on the PAX network. You can clearly see how the body of the creature becomes smaller as it gets farther away from the viewer. Overlapping helps, too: the talons overlap the branch and ground; the head overlaps the collar, chest, and leg; and the body overlaps the hind leg, etc. This overlapping helps the eye see what is closer and what is farther away, providing the perspective that gives the drawing its 3-D impact.

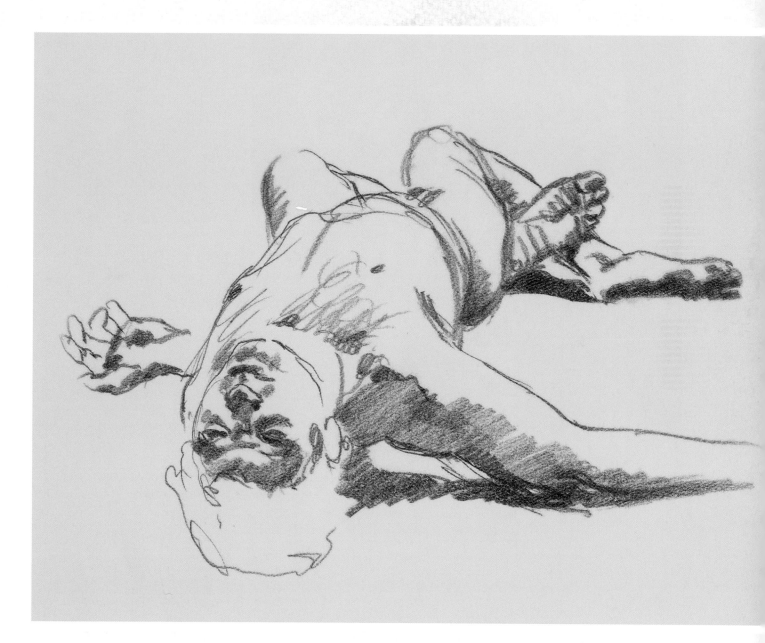

With its dramatic use of lighting and perspective, this drawing by Joe Kubert looks like the figure is the victim of a monster attack, right? Notice how short the legs become in this extreme case of foreshortening. Knowing anatomy is critical to tapering the legs just right, so that they are easily identifiable, even at such an extreme, foreshortened angle. Knowing human anatomy, musculature, and bone structure is necessary for your figures to be believable, especially when foreshortened. It will improve your monster anatomy, too.

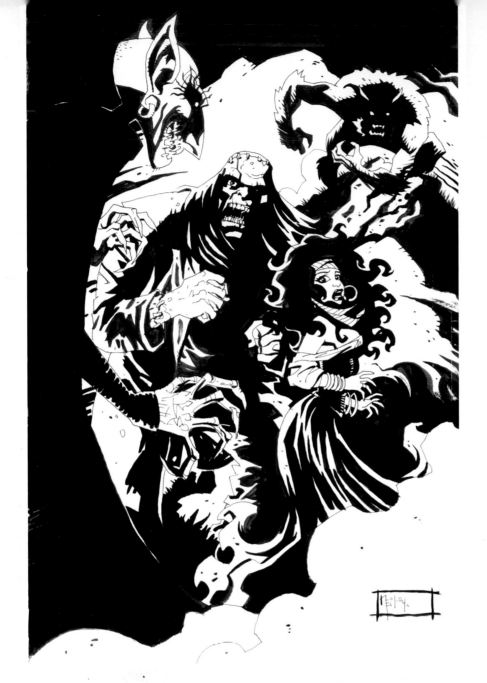

Above is a multimonster mix from Neil Vokes and his *Black Forest* series. In this piece, Neil is using extreme contrast and simplicity of line that is reminiscent of Mike Mignola's *Hellboy* work. It is an excellent example of the use of overlapping figures and reduced size, as figures recede into the depth of the scene to create perspective.

At right, in this superb pencil drawing of Dracula by Gene "The Dean" Colan, the darker passages are ambiguous and slightly swirling. Out of the dark flies the creature of the night, Dracula, king among vampires, with a bevy of bats flocking together as his entourage of evil. Colan captures that surreal, mystical moment when Dracula is in mostly human form but his cloak is still part bat! Can't you just hear the slightly howling wind? Can't you hear how the sound of Dracula's clothes shuffling in the wind folds into the sound of the leathery batwings fluttering? In this, we have a magnificent, extreme-perspective example of how Colan combines figures and clothing from his imagination with a near-photographic face and head—*breathtaking.*

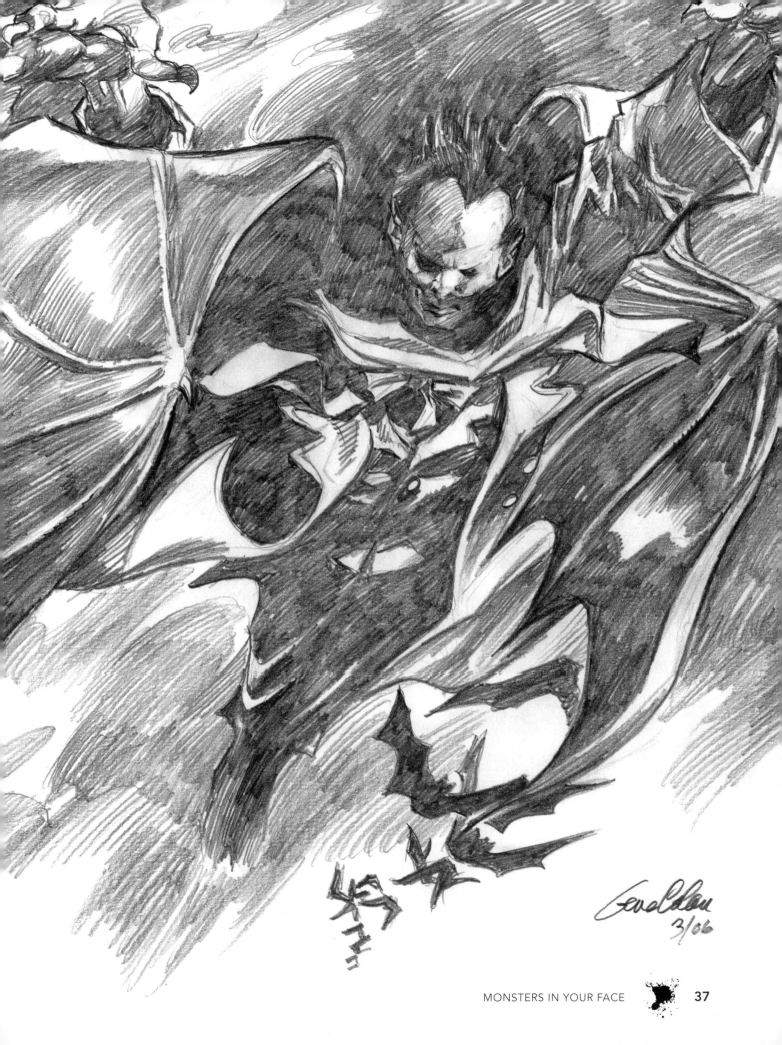

ART © 2002

LIGHT, SHADOW, TONE, AND TEXTURE
Creating Monstrous Dimension

But see, amid the mimic rout
A crawling shape intrude!
A blood-red thing that writhes from out
The scenic solitude!
It writhes!—it writhes!—with mortal pangs
The mimes become its food,
And seraphs sob at vermin fangs
In human gore imbued.

Out—out are the lights—out all!
And, over each quivering form,
The curtain, a funeral pall,
Comes down with the rush of a storm,
While the angels, all pallid and wan,
Uprising, unveiling, affirm
That the play is the tragedy, "Man,"
And its hero, the Conqueror Worm.

—EDGAR ALLAN POE
"The Conqueror Worm," 1843

Menace manifests most in the murky corridors of our minds. Nothing is more frightening than the unknown—the dark. And when we do see what horror emerges from the darkness, it is that which is most unlike ourselves that is most terrifying—textures and tones foreign to us emerging out of the shadows. In this chapter we will focus on light, shadow, tone, and texture.

In this portrait of a Wolfman-style werewolf by master monster portrait artist Basil Gogos, all of the lovely texture, character of line, and technique is built on top of a solid, form-based structure.

CONTROLLING LIGHT IN YOUR DRAWING

Shadow in art is creating darkness on a form and the representation of the lack of light. To shade or shadow something requires an understanding of light, light sources, the lack thereof, and how these things play on the surfaces of objects that are being rendered. For our purposes, that would include vampire fangs, werewolf fur, zombie flesh, and more.

Tone in art has to do with degrees or values of color and/or black. To tone or add tone is to render with a variety of values in tones of black or color. Just as tones in sound or music would be a range or scale of sounds, tone in art can be broken up into any number of values ranging from 0% (no tone or color) to 100% (total saturation of tone and/or color).

Texture in art is the perceived surface quality. *Actual* or *physical texture* is the actual variations of a surface, such as the texture of canvas, wood, or glass. Specific to drawing or visual art, texture is the illusion we create in our images to communicate physical texture.

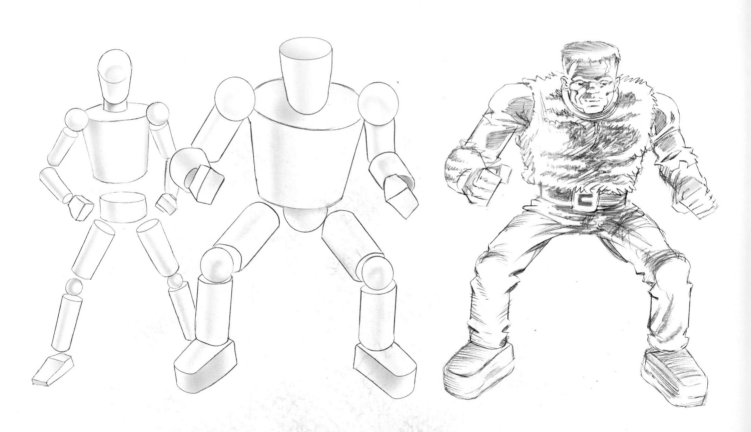

I added tones to the figure made of basic forms from chapter 1 to accentuate the shapes and forms and give a more three-dimensional quality to the figures. By adding clothing details, including folds and wrinkles, and texture, we add drama to the overall drawing, particularly in the shadows. There is nothing more dramatic than an eight-foot monster ready to rip your head off. By thinking of the light and rendering its effects on the grotesque features of a monster, you bring a greater sense of realism to your drawings.

Here I decided the best way to show off the monster's formidable brow and stature was to play up the dramatic effect of underlighting. The shadows on the legs and face indicate that the primary light is coming from below, creating an eerie effect.

NO. 4 THE MUMMY!

BELIEVING IN LITERAL RESURRECTION OF THE BODY, ANCIENT EGYPTIANS CAREFULLY MUMMIFIED AND ENTOMBED THIEIR REMAINS! THE SOUL WOULD DEPART FOR JUDGEMENT BY OSIRIS, BUT THE LIFE-SPIRIT, OR KA, WOULD STALK THE TOMB, AND SHOULD IT BE VIOLATED, RE-ENTER THE MUMMIFIED CORPSE, GALVANATING IT TO TERRIBLE VENGENCE! HIGH PRIESTS OF TOTH, GOD OF MAGIC, COULD ALSO CALL FORTH THE KA-ANIMATED DEAD TO SERVE THEIR EVIL ENDS, TO BE STOPPED ONLY BY COUNTER-SPELLS FROM THE BOOK OF THE DEAD!

Art by Wallace Wood and Dan Adkins

This rendering, by the great illustrator-cartoonist Wallace (Wally) Wood with his associate Dan Adkins, is of an ancient mummy being reanimated. It incorporates tonal drawing techniques and textures to great effect. Wood's use of light and shadow is integral to capturing the atmosphere of the mummy's tomb. The dramatic rim-lighting effects used here are a key signature to the trademark Wood style. This piece began as a rough pencil sketch to establish the composition of the scene and then was further developed in pencil. While the basic figures came from the imaginations of Wood and Adkins, using basic shapes, a movie still photo was used as reference for the mummy's face. Shadows are added in tones of mostly transparent ink wash—ever mindful to make the lighting as dramatic as possible. The final touches are the lightest tones and highlights, which are more opaque.

Here is a basic exercise to help anyone get a good grasp on texture. Get a pencil and paper. I recommend a soft pencil, such as a Sanford Design ebony pencil and a thin piece of paper, such as a sheet of typing, copier, or laser printer paper. Take them and go texture hunting. Look for unique textures and place the paper over them. Then rub the flat side of your pencil lead over the paper to pick up and reveal the texture. These texture rubbings can be made on anything—werewolf hide, vampire caskets, the Frankenstein monster's head. . . . You will figure out quickly what types of textures pick up best and which will get your head ripped off your body. If you survive the exercise, you will have a new understanding and respect for texture.

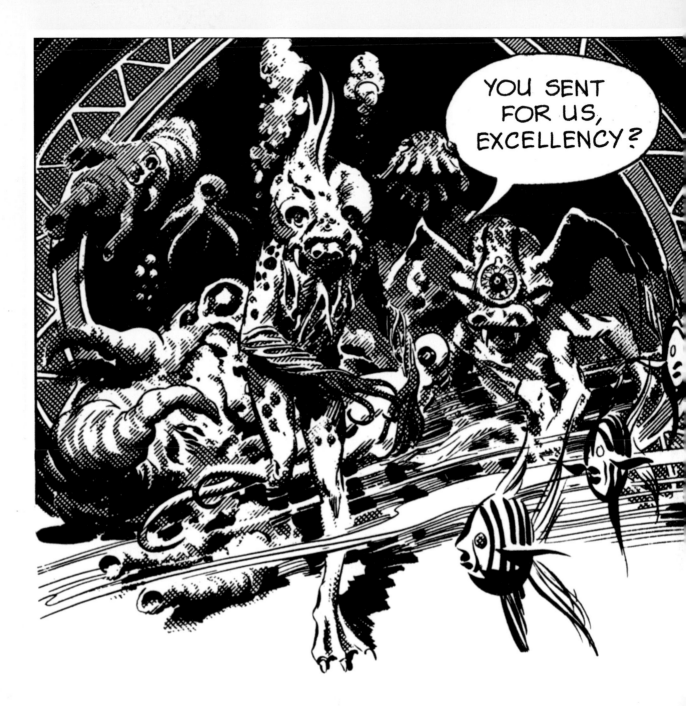

The above image is by legendary ink slinger of great lore Al Williamson. Al, like many horror artists, first came to acclaim drawing for the notorious EC Comics of the 1950s. *Tales from the Crypt*, *Weird Science*, *Shock SuspensStories*, and *The Vault of Horror* were just a few of EC's spine-chilling publications. In the drawing above, from *Creepy* #1 (Warren, late 1964), Williamson integrates the use of Craftint board, or the competing DuoShade board, to produce the unique line-tonal technique. With this board, the artist draws and inks and then applies the provided chemicals to produce/reveal the fine shading lines that come hidden in the board.

Williamson communicates a variety of textures masterfully in each figure and subject in this group of slithering things, in their watery surroundings, and in the background building. The DuoShade board provides unique opportunities in rendering textures. Williamson uses more shading on surfaces that have more texture and less (or none) on smoother, slicker surfaces, such as the lead figure and the fish in the foreground.

FRANK FRAZETTA

THE GRAND MASTER OF FANTASTIC ART

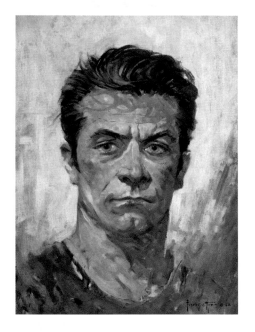

Frank Frazetta self-portrait.
Courtesy of Frazetta Properties LLC.

"Frank Frazetta, an illustrator whose vivid colors and striking brush-strokes conjured up fantastic worlds of muscle-bound heroes fighting with broadswords and battle-axes to defend helpless women from horrible beasts, died on Monday in Fort Myers, Fla. He was 82." Thus started the May 10, 2010, obituary of the Grand Master of Fantastic Art in the *New York Times*—the news spread worldwide, quicker than wildfire.

Frazetta ripped a unique trail through popular culture, the likes of which we do not expect to see again: From *Famous Funnies* and Buck Rogers to Johnny Comet and Lil' Abner; to movie posters for *What's New Pussycat*; *After the Fox*; *The Night They Raided Minskys: Yours, Mine and Ours*; to book covers for *John Carter of Mars*, *King Kong*, and *Tarzan*; to album covers for popular heavy metal bands like Molly Hatchet's *Flirtin' with Disaster* and Nazareth's *Expect No Mercy*; and, of course, *Conan the Barbarian*.

While it may be true that Frazetta is best remembered for his oil paintings, which have sold for as much as $1.5 million, he was equally skilled, and worked nearly exclusively for many years, at producing line art for comics publications. Frazetta's skill with brush, ink, and pen has ever proven a wonder to behold. Just consider his early *White Indian* stories, his much-lauded *Famous Funnies* covers, his work with EC Comics and long-time collaborator Al Williamson, his *Johnny Comet* newspaper strip, and his Edgar Rice Burroughs book illustrations.

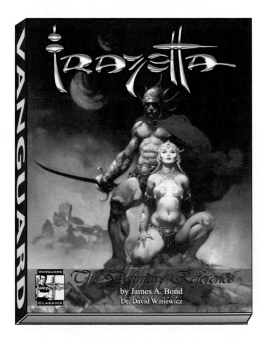

Frazetta: The Definitive Reference (Vanguard, 2008).

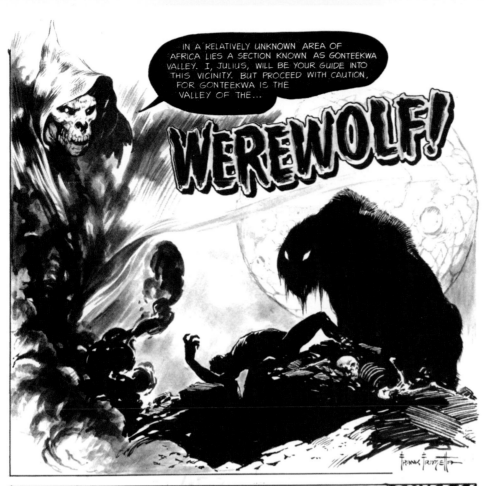

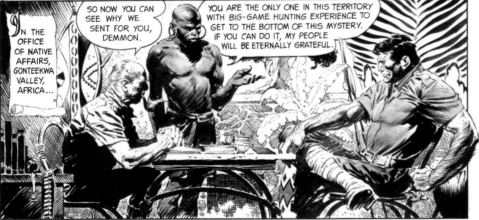

Finesse, power, subtlety, spontaneity, boldness, and sensuality are just a few of the qualities Frazetta brought to his work. Note his various techniques of line and texture in this illustration from *Creepy* #1 (Warren, 1964). The moon; the moody, misty background; the beast; the rocky ground—all feature unique textures. His shading is dramatically shadowy but still done with a subtle, artistic touch. Note also his separation of foreground, mid-ground, and background and his unique design sensibilities in objects surrounding his figures. Hash lines on the lower left panel are more easily produced with a pen than a brush. Time after time, Frazetta shows us a new way, a different way, to see and draw things The Frazetta way. New and different, yes, but always with a classic foundation.

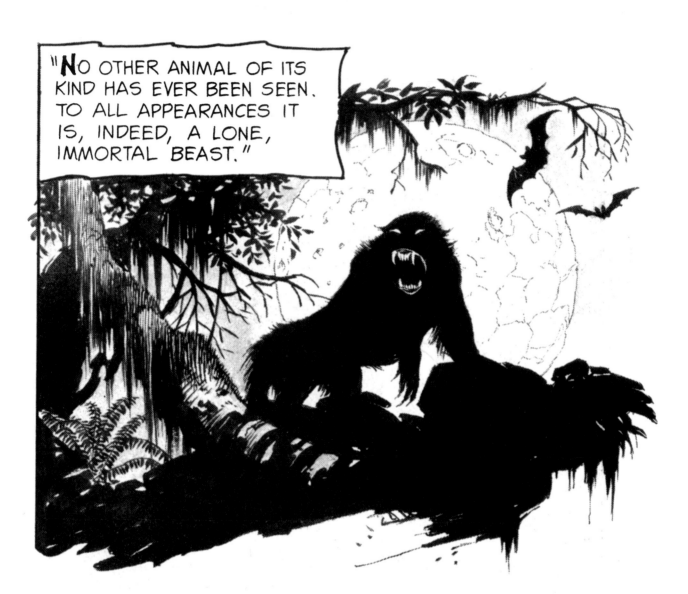

LIGHT, SHADOW, TONE, AND TEXTURE

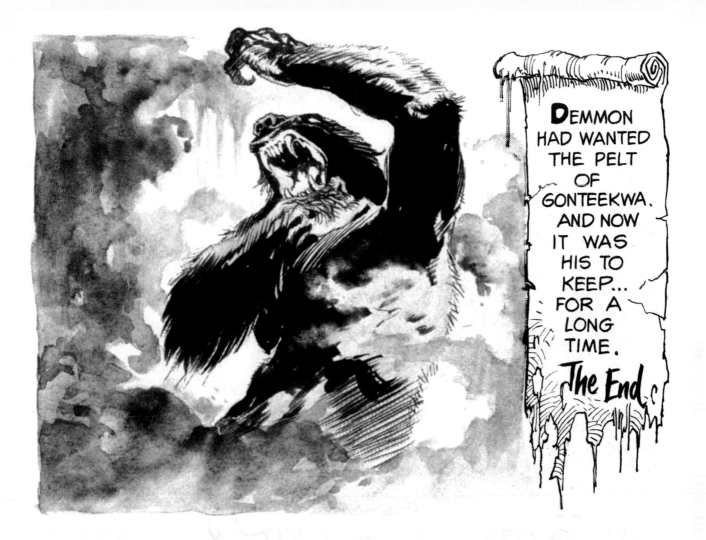

DEMMON
HAD WANTED
THE PELT
OF
GONTEEKWA.
AND NOW
IT WAS
HIS TO
KEEP...
FOR A
LONG
TIME.
The End

In 1964, Frank Frazetta produced his last multipage work of sequential art: the story "Werewolf," for *Creepy* #1 (Warren, 1964). Nobody knew at the time that it would be the last story from Frazetta. He did produce a few single-page sequential pieces after *Creepy* #1, and he did thrill monster enthusiasts with a long line of spine-tingling, oil-painted covers for monster magazines for nearly another decade.

Both drawings here are from "Werewolf," and they are a fascinating combination of line and tonal rendering. Frazetta started with rough pencil sketches, also known as thumbnail sketches, to work out his composition and storytelling. Then he tightened the pencils. He used a brush and India ink for the fine, straight lines like those on the table and in the background seen on page 45. The lush and dramatic, often almost silhouette, images are power-ful and classic examples of chiaroscuro. But Frazetta's use

of tone adds depth and atmosphere and gives us an early hint of what he would be capable of doing with paint. Every masterful stroke exudes the unique Frazetta style. Since this work, he has become the most influential and imitated fan-tasy artist of the modern world, if not of all time. But when this work was produced in 1964, it was absolutely revolu-tionary (though based on classical drawing concepts).

His treatment of the creature was unique as well. Today we have plenty of examples of wolflike werewolves, but at the time that Frazetta created this masterpiece, werewolves were thought of in terms of men with hairy faces and hands, as in the old Universal Pictures *Wolf Man* movies staring Lon Chaney, Jr. Frazetta's approach was a radical departure that could easily have stalked the dreams, or nightmares, of his readers.

Something is out there...
coming CLOSER...CLOSER...CLOSER
Don't be afraid to be afraid—

THEY'RE COMING TO GET YOU!

CHAPTER 5

ZOMBIES
Drawing the Walking Dead

Like one who, on a lonely road,
Doth walk in fear and dread,
And, having once turned round, walks on,
And turns no more his head;
Because he knows a frightful fiend
Doth close behind him tread.

—SAMUEL TAYLOR COLERIDGE
The Rime of the Ancient Mariner, 1798

Benjamin Franklin said, "In this world nothing can be said to be certain, except death and taxes." But let's get real, we all know that (1) it is just a matter of time until the big earthquake hits California, and (2) it is just a matter of time until the inevitable zombie apocalypse!

As most of you know, when the zombie apocalypse comes, the onslaught will be a widespread—or even global—attack upon civilization by an ever-increasing host of hostile, humanity-hating zombies. As victims of the walking dead tend to become zombies themselves, the effect of the crisis will be an exponentially growing outbreak—a veritable zombie plague! Obviously, our law enforcement and military are woefully ill prepared for such hideous and heinous happenings. In addition, widespread panic will likely hasten the ever-so-real collapse of civilization. Among the marauding, flesh-eating walking dead, there will be left only the occasional, isolated pockets of human survivors scavenging for supplies and sustenance in what will be reduced to a hostile, preindustrial, postcataclysmic world.

Original poster art by Basil Gogos for They're Coming to Get You!

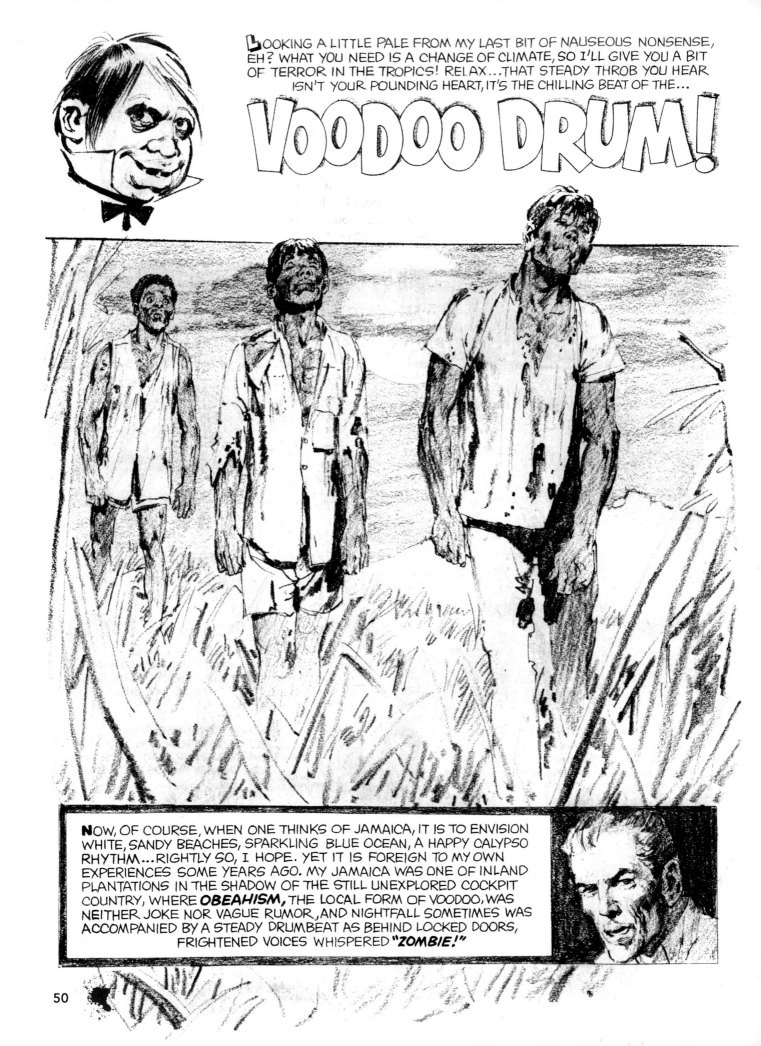

LOOKING A LITTLE PALE FROM MY LAST BIT OF NAUSEOUS NONSENSE, EH? WHAT YOU NEED IS A CHANGE OF CLIMATE, SO I'LL GIVE YOU A BIT OF TERROR IN THE TROPICS! RELAX...THAT STEADY THROB YOU HEAR ISN'T YOUR POUNDING HEART, IT'S THE CHILLING BEAT OF THE...

VOODOO DRUM!

NOW, OF COURSE, WHEN ONE THINKS OF JAMAICA, IT IS TO ENVISION WHITE, SANDY BEACHES, SPARKLING BLUE OCEAN, A HAPPY CALYPSO RHYTHM...RIGHTLY SO, I HOPE. YET IT IS FOREIGN TO MY OWN EXPERIENCES SOME YEARS AGO. MY JAMAICA WAS ONE OF INLAND PLANTATIONS IN THE SHADOW OF THE STILL UNEXPLORED COCKPIT COUNTRY, WHERE **OBEAHISM,** THE LOCAL FORM OF VOODOO, WAS NEITHER JOKE NOR VAGUE RUMOR, AND NIGHTFALL SOMETIMES WAS ACCOMPANIED BY A STEADY DRUMBEAT AS BEHIND LOCKED DOORS, FRIGHTENED VOICES WHISPERED **"ZOMBIE!"**

ZOMBIE ORIGINS

Zombies are creatures that appear most frequently as mindless human beings and/or as the reanimated walking dead. The oldest known recorded accounts of zombies tell of people being controlled as mindless laborers by powerful witchdoctors or sorcerers often known as a *bokor*. These oldest zombie tales stem from voodoo (or vodou), a spiritual belief system most commonly practiced by people of African decent in Haiti and to lesser degrees in other Caribbean islands, including the Dominican Republic, eastern Cuba, some of the outer islands of the Bahamas, as well as parts of the United States.

Caribbean voodoo traces its roots back to the West African religion of Vodun and other African traditions, including those from the kingdom of Kongo. The raising of zombies is the work of a bokor, who is not an official voodoo priest of the Loa. Many practitioners say it is not properly a part of the official voodoo religion and do not approve of the raising of zombies.

Knowledge of and concern about zombies has risen considerably since George A. Romero's shocking 1968 film *Night of the Living Dead*. The high level of zombie integration into popular culture is also evident by their starring role in John Landis and Michael Jackson's innovative fourteen-minute musical short film *Thriller* (1983); the 2005 launch of the popular comic book series *Marvel Zombies*; and in the AMC channel's *The Walking Dead*, which debuted in 2010.

Zombies are typically reported to be and depicted not only as mindless but also as decaying corpses with a hunger for human flesh and brains. The decaying of their bodies gives them a shambling way of walking—just about what you would expect from the walking dead. As the flesh-hungry undead, they have much in common with vampires and ghouls. Also as the flesh-hungry undead, they can be traced back much further than African Vodun, dating to one of the oldest texts ever written: *The Epic of Gilgamesh* (earlier than BCE 1,000), which describes the goddess Ishtar controlling zombielike creatures.

At left is a lesson in how to draw zombies from legendary *Batman* and *Deadman* artist Neal Adams: Instead of ink, Neal uses pencil with varying textures and character of line to produce tonal finished art.

Above is a superb sequence by EC, *Creepy*, and *MAD* artist Angelo Torres. Notice how Torres's darkening around the subject's eyes incorporates contrast to make the eyes look like they are glowing.

At left is a classic Roman zombie, perfectly rendered in ink by Comic Book Hall of Fame artist Al Williamson. Williamson is best known for his EC Comics *Star Wars* newspaper strip and Flash Gordon work, but his brush and ink are perfect for anything, including exposed bones and rotting flesh, as we see here.

Below we see another lesson in how to draw zombies from Neal Adams. The zombies—led by a voodoo practitioner/bokor—bear a variety of expressions, but all have that faraway, glazed-over look, and their flesh is just starting to decompose.

At left we have a sweet young damsel in distress by Neil Vokes—just the kind of treat a zombie loves to get his decomposing hands on. By using contrast, Vokes makes the damsel look sweeter (because she's suffused in light) and the zombies look nastier (because they are cloaked in dark shadows).

DAVID HARTMAN

ZOMBIES, SKUNK APES, AND THINGS THAT GO BUMP IN YOUR HEAD

A twelve-year veteran of television animation, the multitalented Hartman has worked as an Emmy Award–nominated director, producer, illustrator, and character designer throughout his career. Hartman's directorial credits include *My Friends Tigger & Pooh* for Disney, *Roughnecks: Starship Troopers Chronicles*, the animé series *Astro Boy* for Kids WB, *Jackie Chan Adventures*, and many more.

Other Hartman film and TV credits include *Transformers: Prime*, *Heavy Gear*, *Godzilla: The Series*, *Electra Woman and Dyna Girl*, *Lenore* (Web cartoons), *Big Guy and Rusty*, *Extreme Ghostbusters*, *Masters of Horror* for Showtime, *Book of Daniel* for NBC, *Tenacious D in the Pick of Destiny* (New Line Cinema), *The Sarah Silverman Program*, and *Spider-Man* (MTV), for which he earned accolades for his unique designs.

A favorite of Rob Zombie's, Hartman has worked on *Hellbilly Super Deluxe* and numerous comic projects, and he directed Rob's *American Witch* and *Lords of Salem* music videos, which can be seen in concert on the tour screens. David worked as the visual effects supervisor on the cult film *Bubba Ho-Tep*.

In addition to his animation work, Hartman is an award-winning illustrator whose artwork graces numerous comic books, magazines, and music album covers. Publication art includes Steve Niles's *Strange Cases*, *Sideshow Monkey: The Art of David Hartman*, *Sasquatch Anthology* (Viper Comics), *Devil's Rejects* comic book (IDW), *Nocturnals: Midnight Companion*, as well as numerous comics, including *Scud*, *Cemetery Blues*, *Revere*, and *Fear the Dead*.

Hartman's indie short films include *Freako Asylum*, *Ghost Town*, *Mindblower*, *Codename: Embryo*, *All Monsters Must Die!!!*, *Freaks of the Moon*, *Laser Fart 3–7* (with creator Dan Harmon), and *Adventurous Und Magick Haus*.

Awards include four Emmy nominations, including two for Best Director; a Silver Award in the Comics category in the 13th Spectrum Annual of Fantastic Art; the award for Best Flash Animated Short at the Animation Celebration convention; and four Channy Awards for Short Films: Best Director, Best SFX, Best Animated Series, and Best Cinematography.

Make no mistake, though: No matter what he is working on, zombies are always near. On the following pages, the artist shares his thoughts on some of his most memorable zombies!

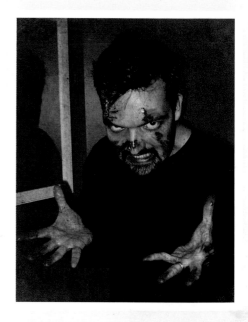

David Hartman, courtesy of the artist.

David Hartman's art book *Sideshow Monkey*.

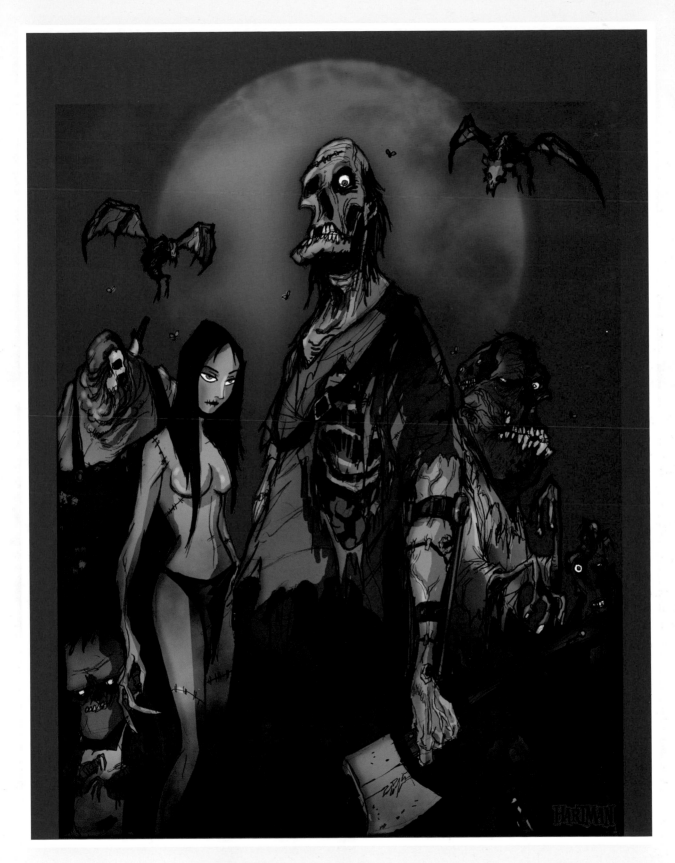

Zombies on the hunt for fresh flesh to devour, exposed bone, flying rats, gnats, maggots, and a stitched-together zombie chick make this piece by David Hartman, entitled *Zombie Squad*, so captivating.

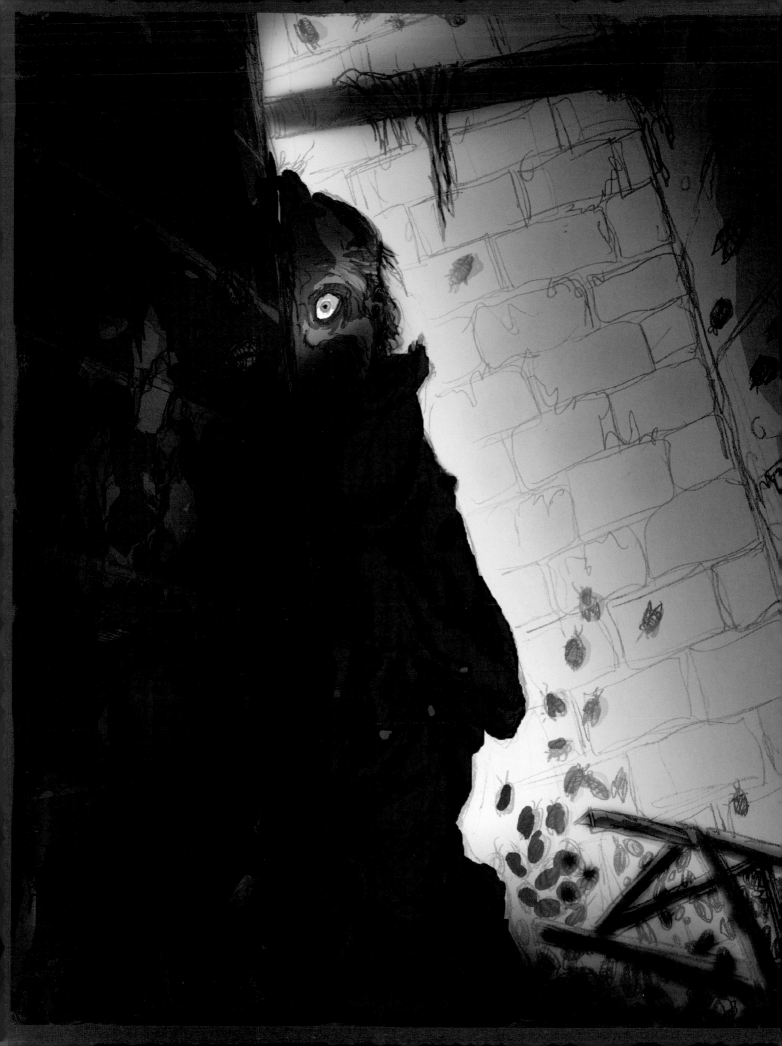

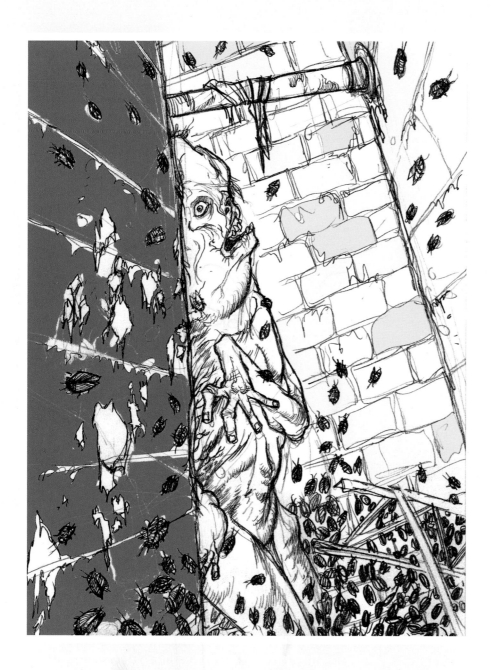

" I love to draw twisted and deformed creatures and the atmospheres they inhabit. Before I start a drawing I usually have an idea of what world I want the creature to live in. With that in mind, I draw fairly rough on crappy copy paper, getting the basics down but keeping an idea of what will be hidden in shadow and what will be shown. In this case, I really wanted to focus on the eye of the creature more than anything else. I then scan the drawing into Photoshop and do the color work from there. "

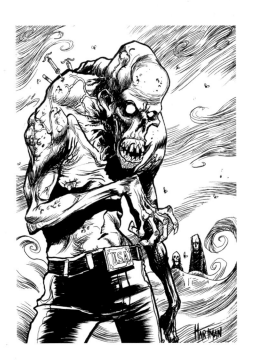

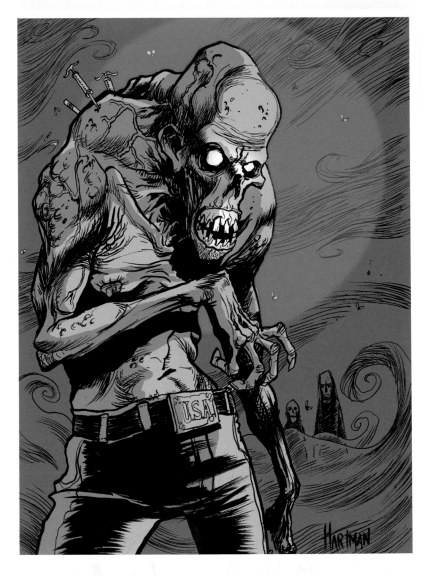

> I clearly remember that I did this drawing while having old monster movies playing on the television, which is always a huge inspiration. This piece was done with a brush pen on 8.5 x 11 copy paper and then scanned into the computer and colored with Photoshop. I knew that I wanted to do this piece in a pseudo–black and white to mimic the feel of those old monster movies. Strong lighting and shadows on the main figure were used to help solidify the zombie's anatomy.
>
> One of my favorite things about this image is the "USA" belt buckle the zombie is wearing. Although he is a reanimated corpse, he still remains patriotic to his country.

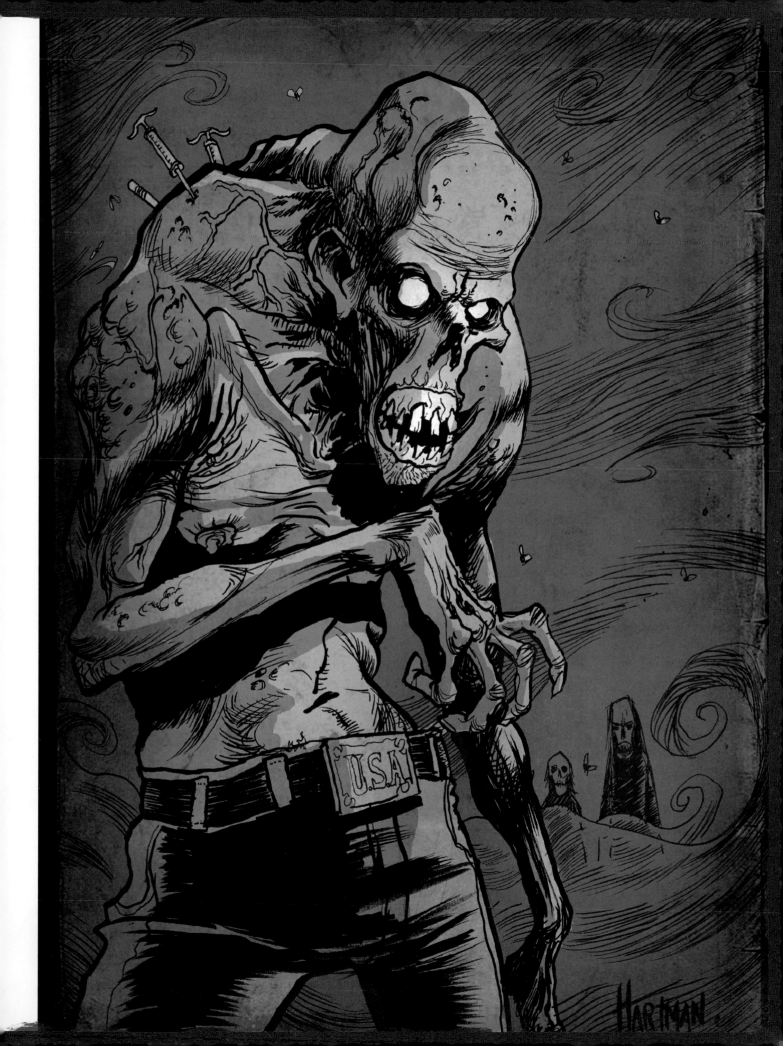

"You can't go wrong with zombies at the Moulin Rouge. I really wanted to try a piece with a lot of different light sources and garish colors. The lighting is always a very important element to me; it is as important as the main figure itself, as it adds an atmosphere and mood to the entire image. With this piece in particular, I tried to give the look of a black light shooting upward on the main zombie while using a pink (a color you don't often see with zombies) in the background to help him "pop" out.

On big set pieces like this one, I tend to blur the background slightly to add a sense of depth and help the foreground characters stand out. "

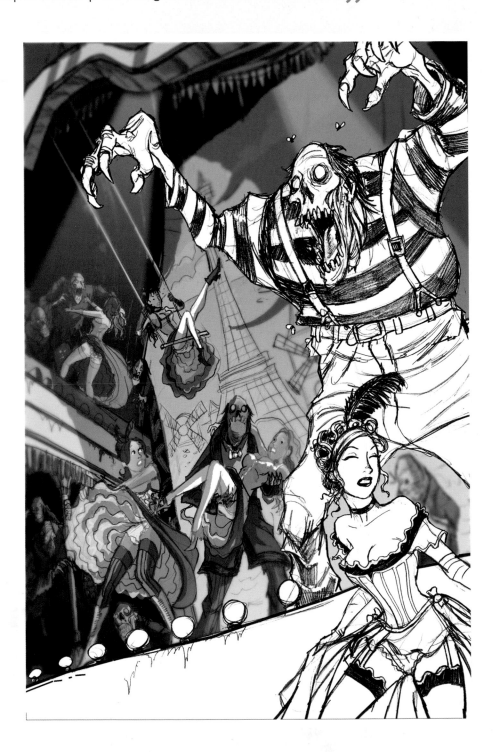

ZOMBIES

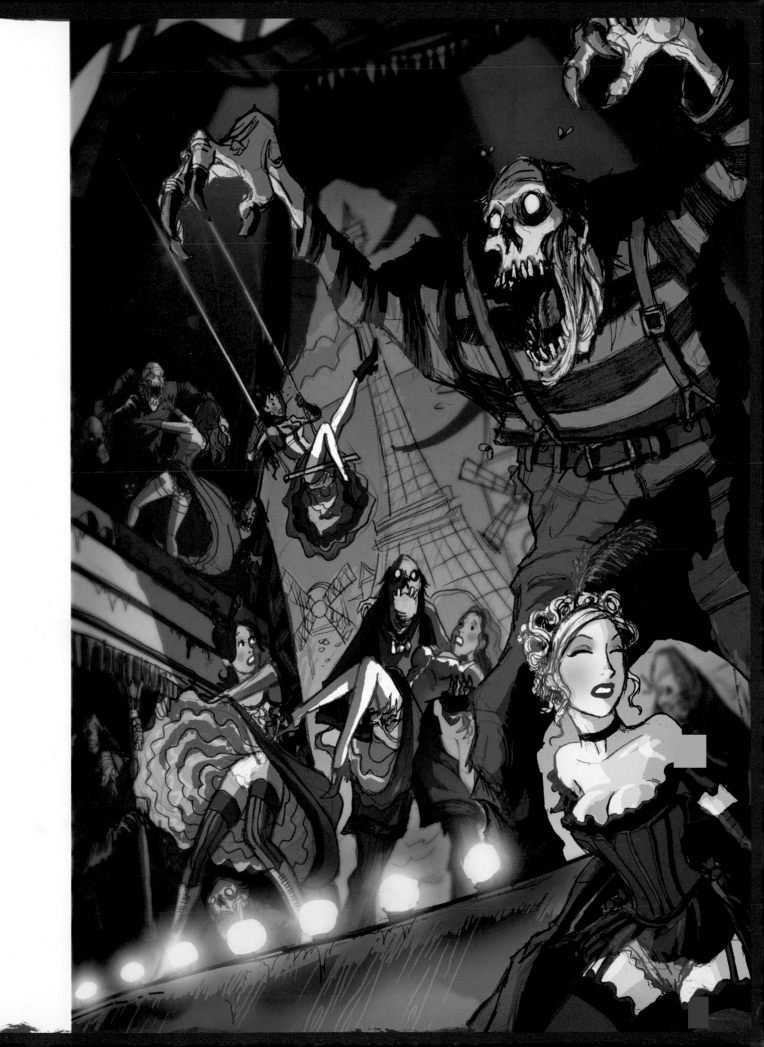

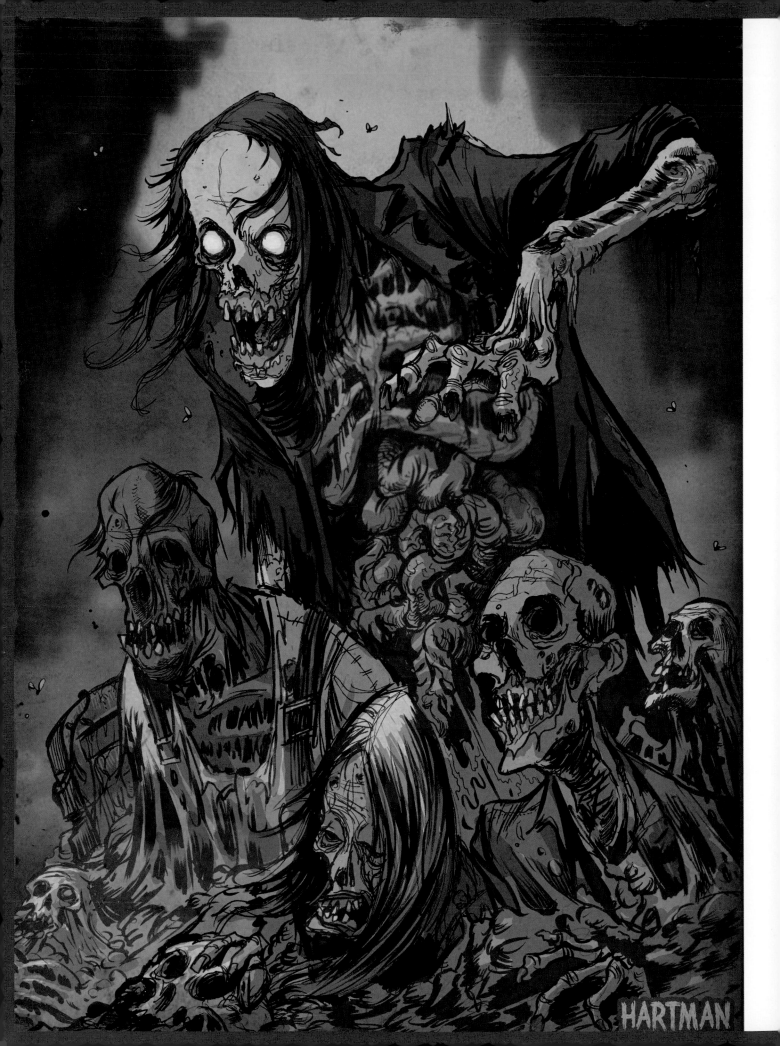

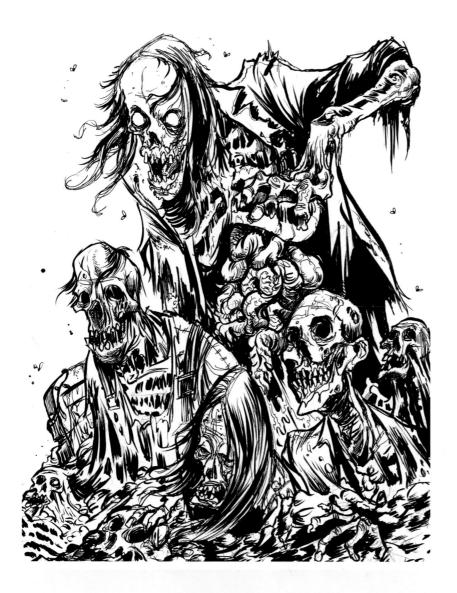

" When I was a kid, my parents would buy me boxes of old comics from flea markets. The majority of them were old pre-code horror comics, and I always loved seeing the imagery of the undead crawling out of the mud. I really wanted to catch that same feeling I had as a kid in this piece. I first drew this image in pencil and then inked it with a brush pen before taking it into Photoshop for the color.

I wanted this piece to convey the brown hues of mud and feel desaturated while still having a lot of color within the piece. I tried to use the contrast of blue against the brown tones to help bring the characters to the foreground as well as give an unsettling feel to them as they rise from the grave. **"**

"In addition to always having zombies in my art, I also tend to add the ladies quite often. Most of the time the women themselves may be just as dangerous or more so than the creature itself. In this case, I thought the woman was probably this thing's captor and would send the zombie out of the swamp to look for food.

I was happy with how this piece turned out, and it has been one of my recent favorites. This was drawn with a thin pen to get a scraggly feel to the art, to add a lot of texture that mimics the bark of the old trees in the swamp."

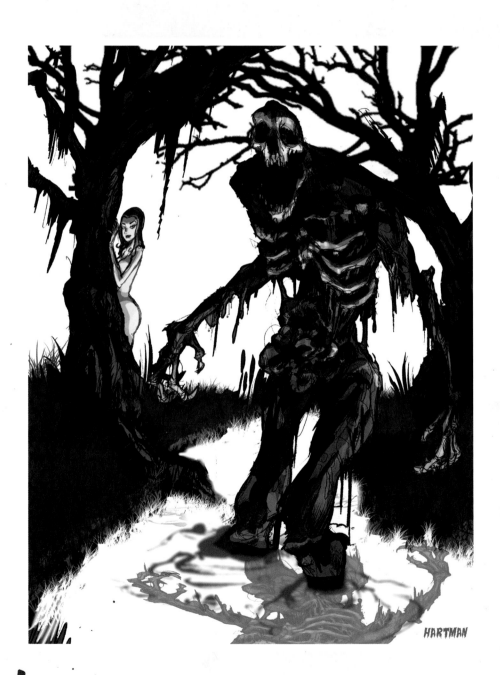

ZOMBIES

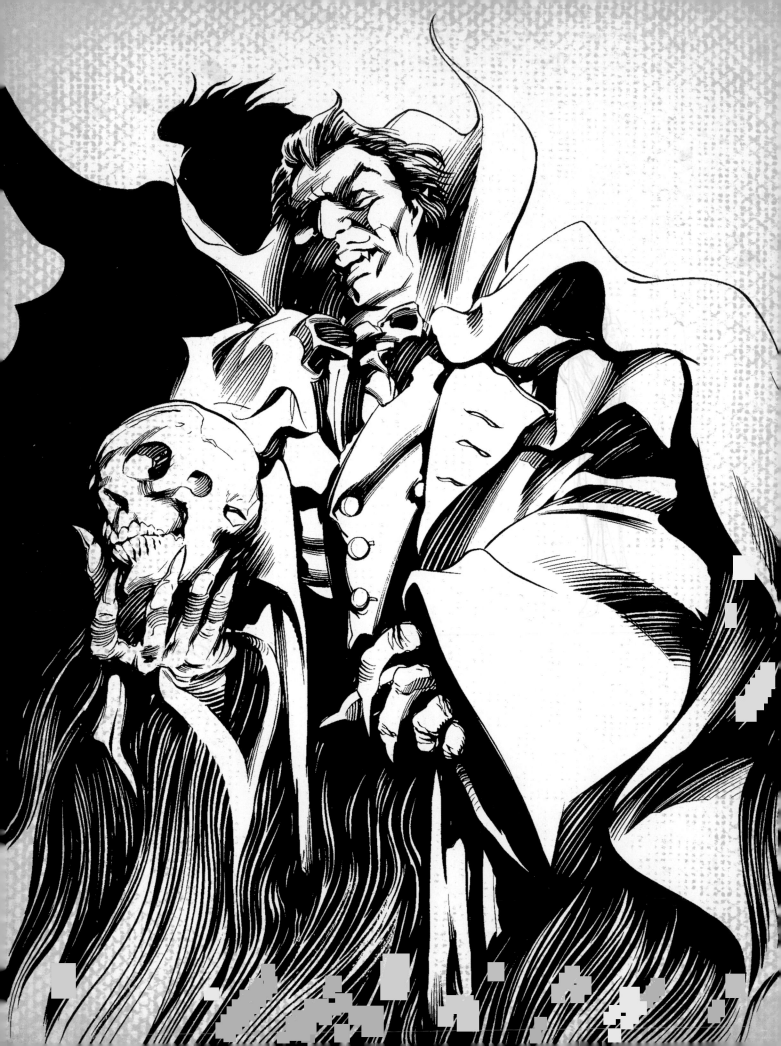

VAMPIRES
Drawing the Living Dead

By night, when, wrapt in soundest sleep,
All mortals share a soft repose,
My soul doth dreadful vigils keep,
More keen than which hell scarely knows.

There, vested in infernal guise,
(By means to me not understood,)
Close to my side the goblin lies,
And drinks away my vital blood!

—JOHN STAGG
"The Vampyre," from *The Minstrel of the North*, 1810

Promises, promises: The Prince of Darkness, the Serpent, Ol' Slue Foot . . . Evil has endless names. But Evil is out to trap the innocent with promises that are only filled with twisted ironies and contradictions. The promise of everlasting life becomes the damnation of existence in everlasting darkness. The promise of endless, lustful passion is fulfilled with the realization that as a vampire you turn love into a curse, an abomination. A word to the wise: Don't get sucked in.

A brush-and-ink rendering of Dracula by
Gene Colan and Dave Gutierrez.

VAMPIRES THROUGHOUT THE AGES

Vampires subsist by feeding on the life force of living creatures—most commonly the creature's blood. Vampires often visit friends, family, and loved ones and inflict death in the regions they inhabited when they were alive. Older vampire accounts report them wearing shrouds and looking bloated and ruddy and having a dark countenance. Beginning in the early nineteenth century, they were described as gaunt and pale.

Tales of bloodsucking demons have been recorded in many cultures throughout time. They are known by different names, such as *strigoi* in Romania, *vampir* in Serbia and Bulgaria, and *vrykolakas* in Greece. It was in the early eighteenth century, after an influx of vampire reports spread from the Balkans and eastern Europe into western Europe, that the term *vampire* became most widely used. This influx also led to vampire hysteria and in some cases resulted in vampire hunts and corpse stakings.

In 1819, with the publication of *The Vampyre* by John Polidori, the vampire of modern fiction was born. The story was highly successful and portrayed vampires as charismatic and sophisticated. It is arguably the most influential vampire work of the early nineteenth century. However, it is Bram Stoker's 1897 novel *Dracula* that became the quintessential vampire novel, providing the basis of most modern vampire lore.

Stoker's *Dracula* was loosely based on the historic figure known as Vlad the Impaler, also known as Vlad III, Vlad Tepes (meaning Impaler), and his actual Romanian surname of Draculea (sometimes spelled Drakulya). Draculea means *Son of the Dragon*, which can refer both to Satan and to Vlad's birth father, Vlad Dracul. (In Latin, Draco means Dragon; in Romanian, Drac simply means Devil.) The moniker of Dracul was bestowed upon him when he joined the Order of the Dragon, a monarchical, chivalric order for selected nobility, created in Hungary in the late Middle Ages. The historic Draculea was a three-time Voivode (ruler) of Wallachia, frequently in power from 1456 to 1462. He and his Draculesti relatives often reigned in Wallachia (and sometimes the neighboring Transylvania) as late as 1600. Vlad Draculea was best known for his resistance against the expansion of the Ottoman Empire and the excessively cruel punishments he imposed on his enemies (and sometimes his dinner guests). Wallachia united with Moldavia in 1862, which ultimately led to the creation of Romania.

The success of *Dracula* spawned a distinctive vampire literary genre, which is more popular in the twenty-first century than ever, with books, films, video games, and television shows.

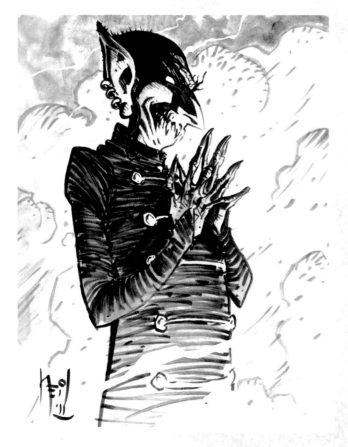

At left is a wash sketch by Neil Vokes, inspired by *Nosferatu*, F. W. Murnau's 1922 German Expressionist vampire film, starring Max Schreck as Count Orlock. *Nosferatu* was an unauthorized adaptation of Bram Stroker's *Dracula*, in which vampires were referred to as Nosferatu.

Opposite is a Basil Gogos charcoal/Conté drawing of Bela Lugosi as seen in the 1932 film *White Zombie*.

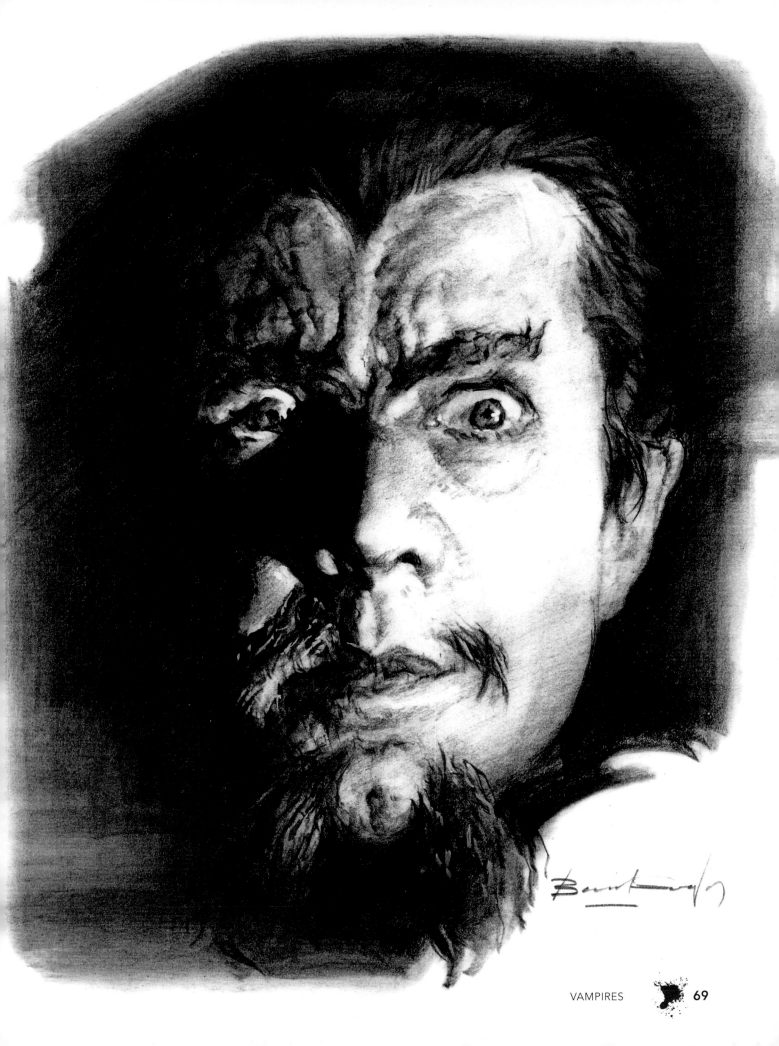

I found this brilliantly executed Basil Gogos depiction of Bela Lugosi as Count Dracula so captivating that I acquired the original to hang in my private collection.

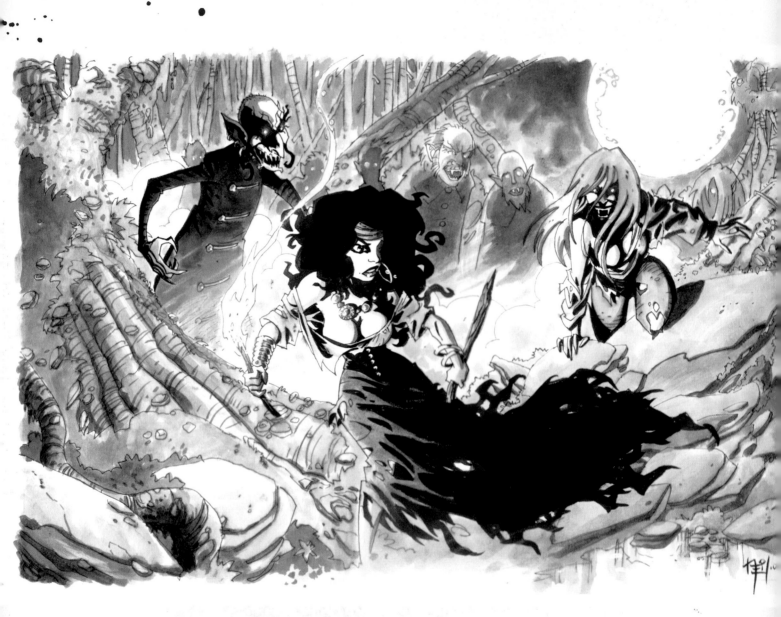

This moody tonal drawing by Neil Vokes is from his marvelously macabre *Black Forest* graphic novel.

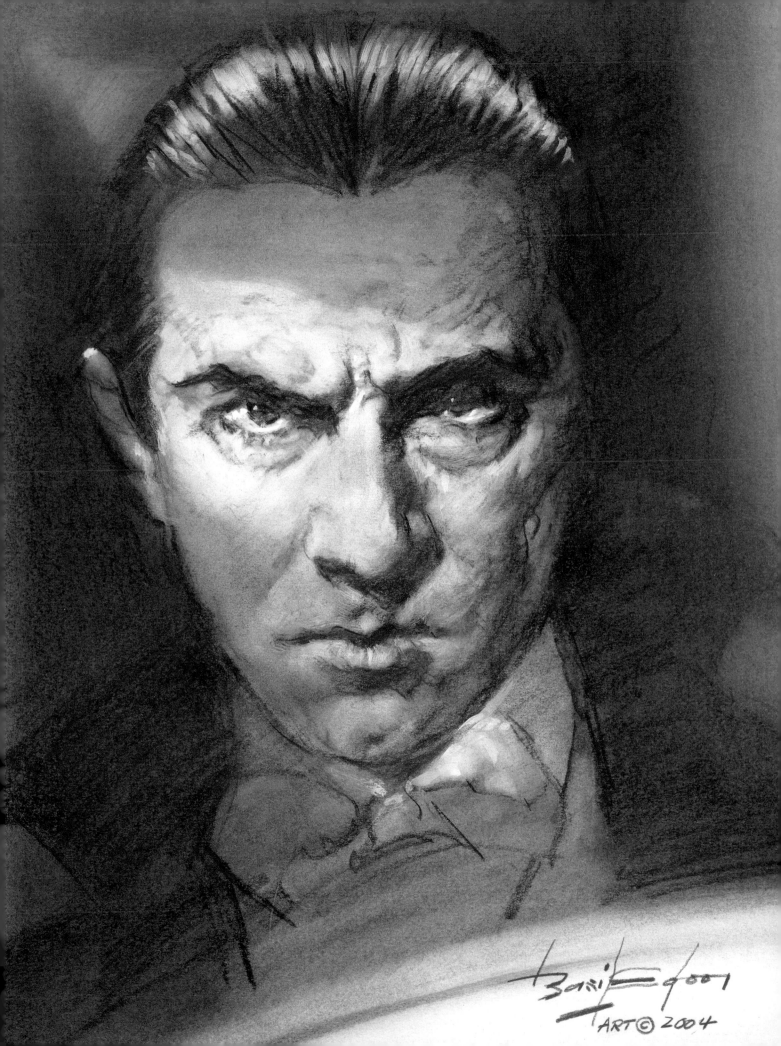

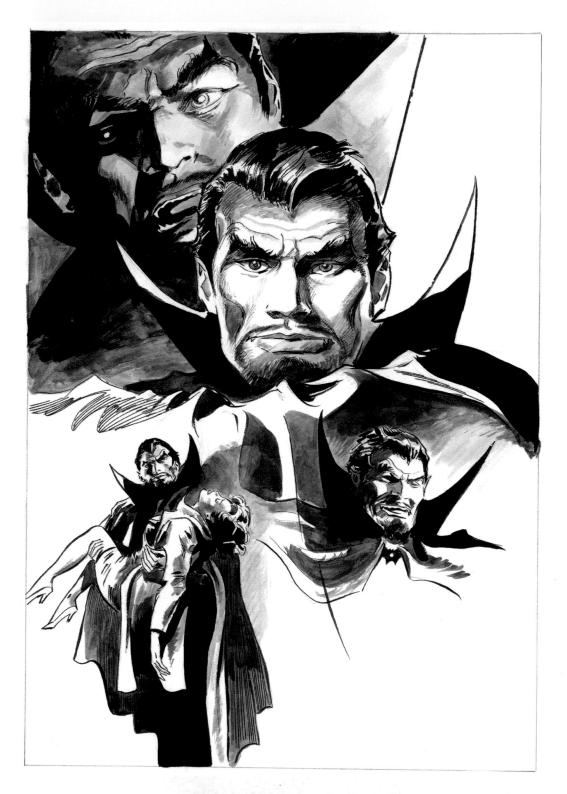

When the death-grip of the Comics Code censorship board finally started to loosen in the early 1970s, Marvel Comics decided to compete with Warren's roster of horror magazines by launching their own line of monstrous musings, which included *Dracula*, *The Frankenstein Monster*, *Tales of the Zombie*, and *Werewolf by Night*, and featuring characters such as Morbius (a vampire), Satana (to compete with Vampirella), and their fiery-skulled motorcycle-riding Ghost Rider. To ensure that he landed the Dracula assignment, Gene Colan produced this terrific tonal study as an indication of his affinity for the continental Count.

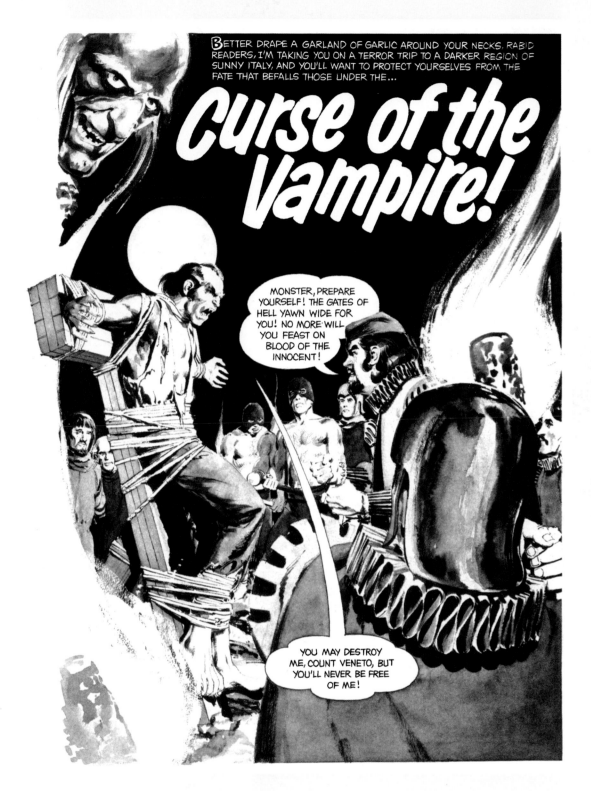

This is the splash page to Neal Adams's "Curse of the Vampire," from *Creepy* #14. Adams was a young artist out to prove himself amidst the cream of the crop of seasoned *Creepy* art professionals, including Frazetta, Ditko, Williamson, Morrow, Davis, Colan, and Wood. And prove himself Adams did, with polished commercial illustration techniques, realism, great anatomy, fine line work, dramatic lighting, and moody ink-wash rendering. Within a few short years, Adams's meteoric rise would introduce his work to the broadest of comic book audiences on features like *Deadman*, *X-Men*, *Green Lantern*, *The Avengers*, and *Batman*.

GENE COLAN

THE DEAN OF COMICS DRAWS THE MOST DIABOLIC VAMPIRES ON EARTH

From the original Bram Stoker novel *Dracula*, to *Nosferatu*, to the classic Bela Lugosi Dracula films, to the great Hammer films with Christopher Lee and Peter Cushing, to *Dark Shadows*, *Interview with a Vampire*, and *Vampire Diaries*—all are important additions to vampiric lore and literature. But for lore, literature, and especially for art, vampire comic books and graphic novels should be included in any significant list, and the various Dracula comics and graphic novels are the most important of all vampire sequential art. While there are notable mentions (like Neal Adams's origin of Dracula in *Dracula Lives* #2), the undisputable king of Dracula sequential art is Gene Colan, who was inducted into the Will Eisner Comic Book Hall of Fame in 2005.

Born September 1, 1926, in the Bronx borough of New York City, Colan reveled in the classic horror films of the 1930s as a boy, starting with *Frankenstein* at the tender age of five. Colan graduated from the George Washington High School of the Visual Arts before studying at the Art Students League under famous surrealistic/modern Japanese painter Kuniashi and illustrator Frank Riley. During World War II, Colan served as a corporal in the Army Air Corps in the Philippines, where his artwork won awards and illustrated the pages of the *Manila Times*.

Colan began his comics career at Fiction House in 1944, before moving onto Timely (Marvel) Comics. In addition to freelancing for numerous independent publishers, including Dark Horse Comics and *Creepy* and *Eerie* magazines, Colan's association with Marvel has run from 1946 to the present day.

Colan's affinity for the mysterious is shown in early Marvel (1950s) titles like *Journey into Mystery*, *Mystic*, and *Menace*. Colan then moved to a more homogenized stint at DC/National, drawing *Sea Devils*, *Hopalong Cassidy*, and romance stories. He returned to Marvel in the mid-1960s, their most creative period. Gene contributed significantly to *Iron Man*, *Sub-Mariner*, and *Captain America*, but with *Daredevil* and especially *Dr. Strange*, Colan's unique talent for the mysterious came to full bloom.

Colan's moody, shadowy, dramatic drawings filled his unprecedented run on *Tomb of Dracula* with writer Marv Wolfman (throughout the 1970s). He chose to base his characterization of Dracula not on Bela Lugosi or Christopher Lee but on Jack Palance. Ironically, Palance, who had never played in a horror film, was cast as Dracula a year after Colan's Dracula premiered. Colan's Dracula work wasn't

Photo of Gene Colan, courtesy of David Armstrong, © 2011.

The Invincible Gene Colan collects the work of the famous Dracula, Iron Man, and Dr. Strange artist.

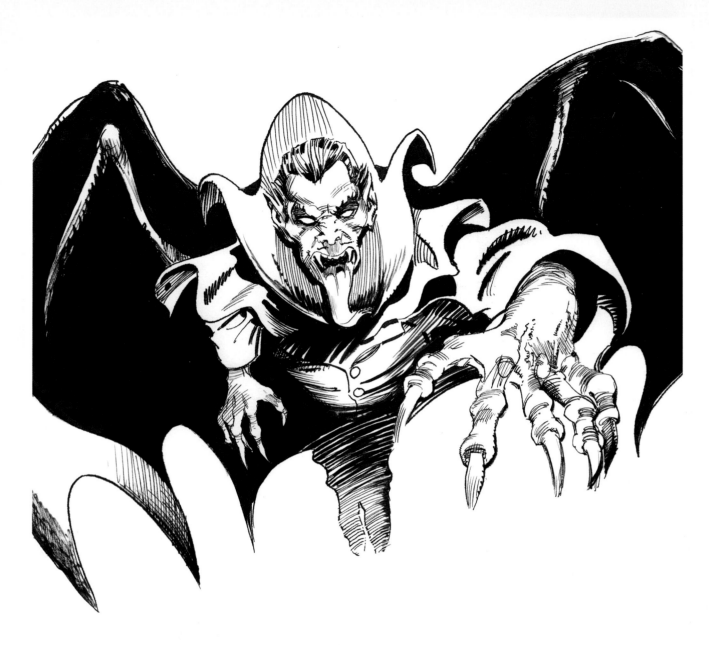

limited to comic books or Marvel or the 1970s. In addition to the *Tomb of Dracula* comic book, Colan produced Dracula annuals, magazines, graphic novels, and miniseries for Marvel and Dark Horse into the 1990s. In the 1980s, Gene took the dramatic lighting and moody pencils he so brilliantly revealed in *Dr. Strange* and *Dracula* to DC with work on Batman; *Nathaniel Dusk*; *Night Force*; and *Jemm, Son of Saturn*.

Gene's fantastic 2002 graphic novel *The Spider: Scavengers of the Slaughtered Sacrifices* (written by Don McGregor and published by Vanguard) pitted the classic pulp fiction character the Spider against the villainous Slaughterhouse Skeleton.

Colan's beautiful pencil rendering conveys the horror of Dracula's imminent arrival.

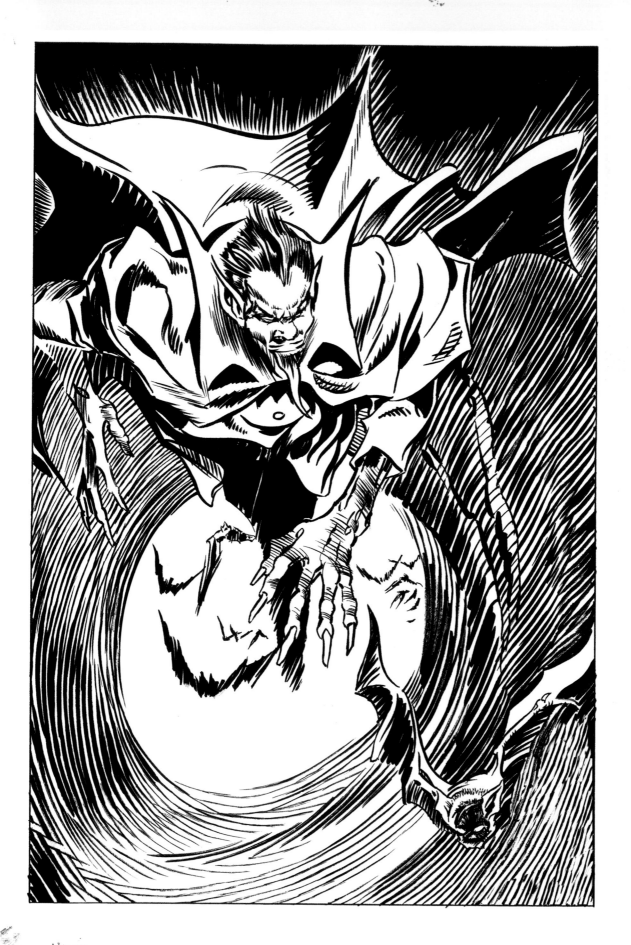

VAMPIRES

At left, we see Dracula hovering in the moonlight above an unsuspecting world in this moody, perspective-driven composition by Gene Colan and J. David Spurlock.

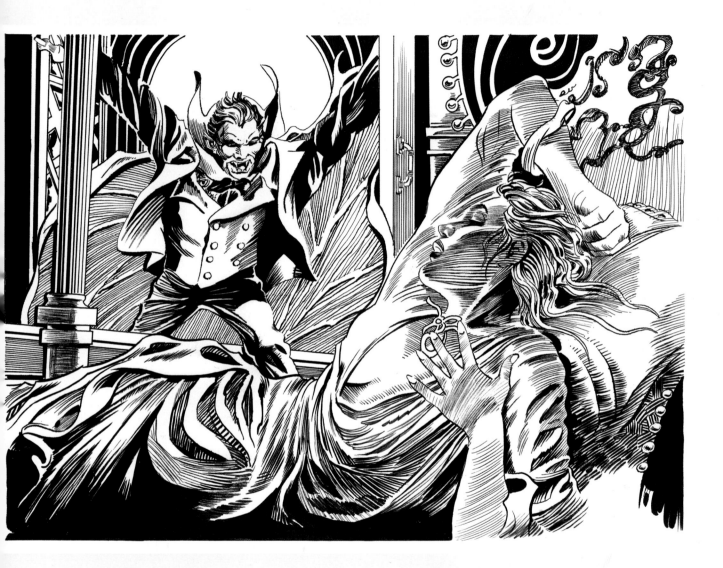

Count Dracula must feed upon the blood of humans. Some human blood is sweeter than others. Tonight, in this lavish drawing by Gene Colan and J. David Spurlock, our Count can count himself one lucky vampire.

BUT I *RESENTED* HIM. I *RESENTED* HIS *PRESUMPTION* UPON A *HIGHER* POWER. I RESISTED HIS *ATTEMPTS* ON MY *BEING!*

I DID NOT *WANT* LIFE! SO I DID NOT *RECEIVE* IT!

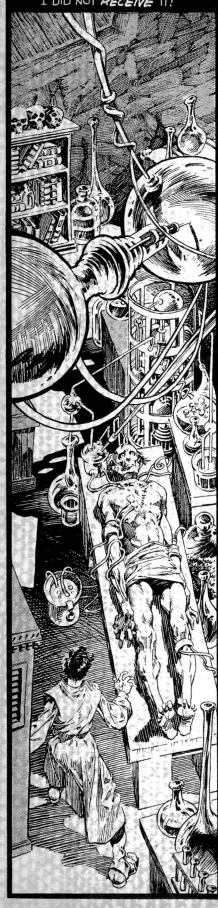

AND MY CREATOR *RAGED.*

HE TURNED *OFF* HIS MACHINES AND SCREAMED AT MY LIFELESS FORM. HE *CURSED* ME... FOULLY, *THOROUGHLY!* HE BLAMED *ME* FOR HIS FAILURE!

BUT I DID NOT *WANT* HIS GIFT OF CREATION. I *REJECTED* IT. I HAD NO *PLACE* IN THE WORLD OF *MEN.*

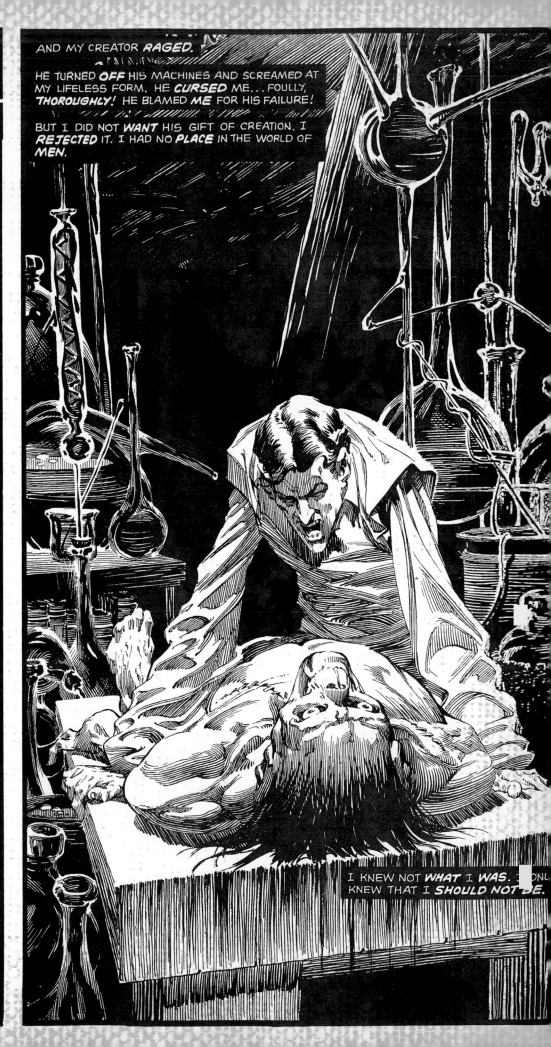

I KNEW NOT *WHAT* I *WAS.* I ONLY KNEW THAT I *SHOULD NOT BE.*

THE MONSTER
Drawing Dr. Frankenstein's Creation

Cursed, cursed creator! Why Did I live?
Why, in that instant, did I not extinguish the spark
of existence which you had so wantonly bestowed?
I know not; despair had not yet taken possession of me;
My feelings were those of rage and revenge.
I could with pleasure have destroyed the cottage and its inhabitants,
And have glutted myself with their shrieks and misery.

—MARY SHELLEY
Frankenstein, 1818

Pathos! Think of the torments of life. The ebb and flow, the good and bad . . . You think you have it rough? Put yourself into the shoes of Dr. Frankenstein's monstrous creation, which Mary Shelley so perfectly made famous in her tome of 1818, *Frankenstein; or The Modern Prometheus.* Like zombies, this monster is something dead that has been reanimated.

Monsters kill and torment and pillage and run amok, terrorizing the innocent, deserving to be hunted down and put out of our misery and theirs alike, but if ever we are to feel empathy, it is surely for that pitiful creature, that monster of Frankenstein.

This fantastic scene is of Dr. Frankenstein's laboratory as he works on his monstrous creation. It is the work of one of the truest masters of the macabre, Bernie Wrightson.

THE FRANKENSTEIN STORY

Dr. Victor Frankenstein assembled the creature in his laboratory out of parts of various cadavers through his unique methods, which combined science and alchemy. Immediately upon bringing the creature to life, Frankenstein fled from it in horror, disavowing his experiment. Abandoned, frightened, and completely without friend or family, the monster, who is likewise horrified by itself, wanders through the world seeking peace but responding to the attacks of people with rage.

Capturing the strength and anger of this monster, along with its inner sorrow and pain in art, is a unique task but one that will call upon similar lessons as other art in terms of form and structure, light and shadow, as well as tone and texture.

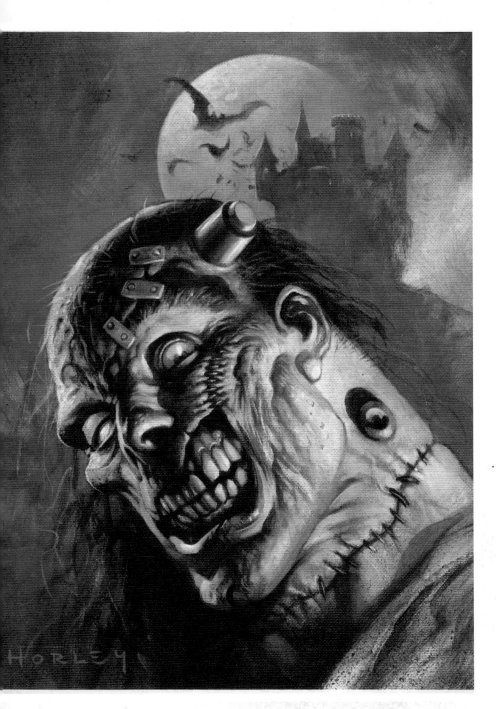

At left, we see a classically rendered painting by Alex Horley, which is a great example of a non-Universal-style Frankenstein monster.

At right, Neil Vokes's tonal ink-wash rendering indicates action as well as the scale/size of the monster.

DEMONSTRATION: FOUR MONSTER STUDIES

On this spread are a variety of Frankenstein monster portraits by MonsterKid.com and Monsterverse honcho Kerry Gammill. Our friend and collaborator, Gammill produces lots of monster designs for film, TV, and toys. His examples here show a variety of treatments for the monster. It is important to remember that Universal Studios holds certain rights to the makeup designs they use in their monster films. So it's advisable that if you are producing Frankenstein art that is not connected to Universal, that you create your own unique treatments. We can see here some that Kerry has come up with, including this three-stage, step-by-step piece.

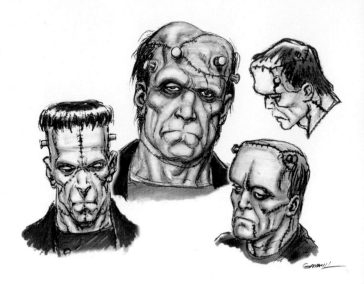

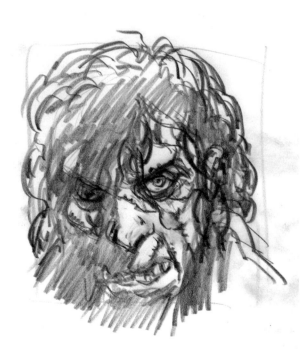

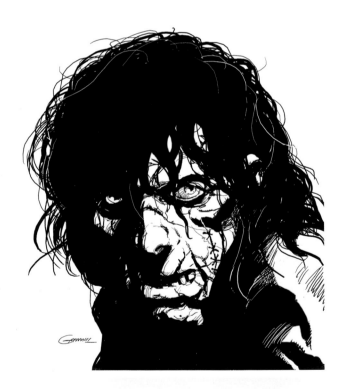

STEP 1: Here we see Kerry sketch in the monster, establishing the basic form as well as the light source. Lighting adds to the dramatic effect.

STEP 2: Kerry inks the drawing using brush and pen. Bold swashes of shadow (also referred to as spot blacks) and limited use of feathering (or line shading) add to the drama and impact of this piece. A few scratchy lines of white in the hair are a specialty effect and add a bit of icing on this monstrous cake.

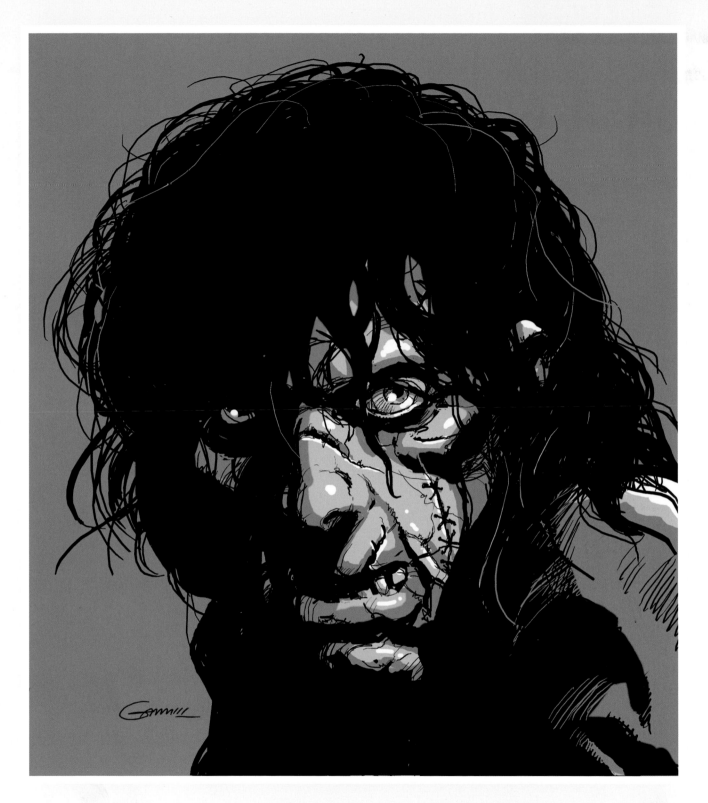

STEP 3: The work is then scanned into a computer and finished with some gray tones and highlights using Photoshop.

BASIL GOGOS

THE WORLD'S GREATEST MOVIE MONSTER ARTIST

Basil Gogos, courtesy of the artist.

Basil Gogos is the acknowledged master of film monster portrait art. To many fans of classic horror movies, the name Basil Gogos is as familiar as that of Boris Karloff, Bela Lugosi, or Vincent Price. Gogos's paintings are as iconic as his subjects. Gogos also produced art for men's adventure magazines, paperback books, movie posters, and other areas.

The "monster craze" among baby boomers, sparked by the release of Universal Studios's horror classics to television in the late 1950s, gave birth to a new phenomenon—the monster magazine. *Famous Monsters of Filmland*, filled with monster photos and articles on horror movies and their stars, was the premier publication for young horror film fans.

Issues of the new magazine practically leapt off the newsstand shelves and into kids' hands due in no small way to their striking cover paintings by Basil Gogos. Like a Bizarro World Norman Rockwell, his stylish portraits of horror film characters and stars were seen on magazine covers throughout the 1960s and 1970s. Gogos's interpretations of movie monsters like Frankenstein, the Creature from the Black Lagoon, and the Phantom of the Opera breathed new life into the old black-and-white images. His amazing use of color and bold, impressionistic brushwork gave a sense of both excitement and sophistication to his paintings, which has never been matched.

Gogos's legend as the world's greatest movie monster artist has only grown over the years. His original *Famous Monsters* cover paintings are highly sought after and are in the collections of many filmmakers and rock stars on whom he made a lasting impression. In recent years he has been in much demand by producers wishing to capture the unforgettable look and feel of the classic monster art of the 1960s. CD and DVD covers, movie posters, trading cards, book covers, and new monster magazines continue to keep Basil Gogos the world's greatest monster artist.

Basil's award-winning book *Famous Monster Movie Art of Basil Gogos* features many of his most famous paintings, previously unpublished paintings, and an introduction by rock star and movie director Rob Zombie. In the following pages, Gogos talks about his work.

Basil Gogos's classic tribute in oil paint to Boris Karloff at the time of his passing, as it appeared on the cover of *Famous Monsters of Filmland* #56.

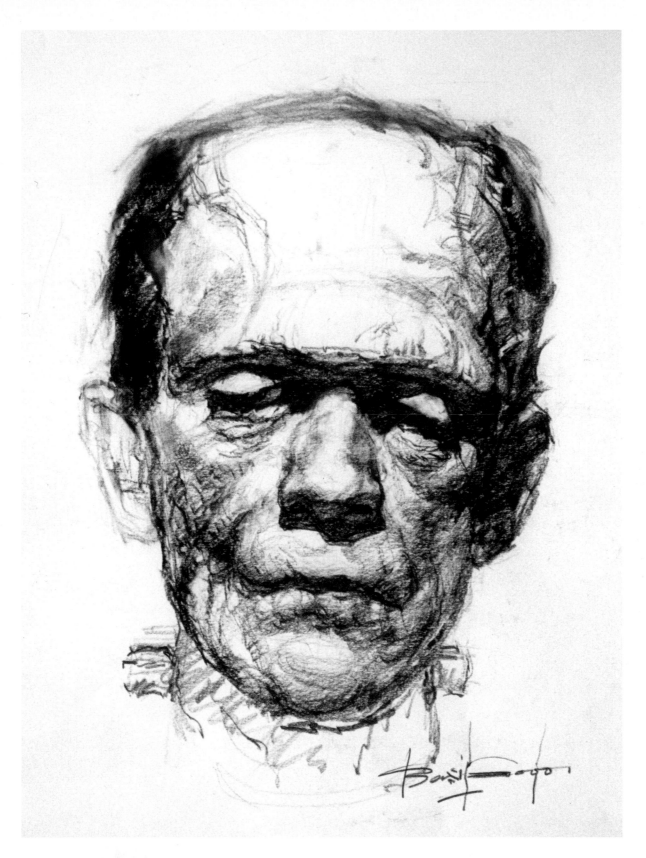

A masterful dry-media rendition of Karloff as the Frankenstein monster, by Basil Gogos.

DEMONSTRATION: THE MONSTER

"I regularly work from photo reference. Once I have picked a photo or photos I want to work from, I begin. For drawings like this, one could use any kind of dry media, like Conté crayon, pencil, or pastel, but I tend to use charcoal."

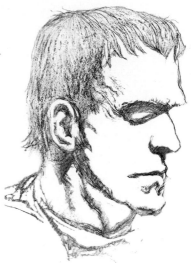

STEP 1: I look at the reference and then very lightly sketch the most basic shape of the subject. As you can see here, the Frankenstein monster's head differs a bit from a regular human head in that it is flatter, both at top and in the front.

STEP 2: I begin to add the contours and features of the face and head. Soft, dry media like charcoal picks up the texture of the paper for a nice artistic effect.

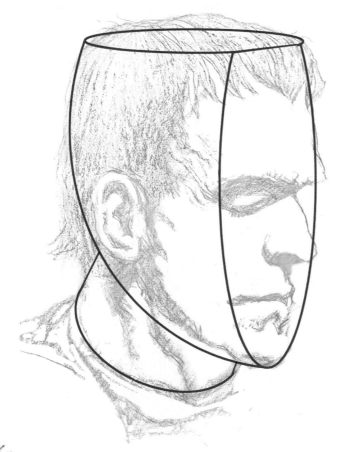

STEP 3: This image combines step 1 with step 2 so you can see how the form of the head breaks down into simple shapes.

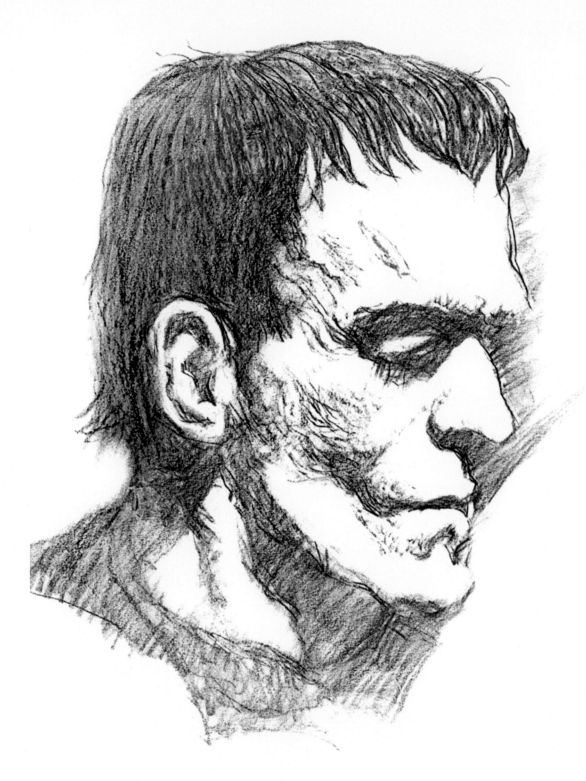

STEP 4: At this stage, you might think the drawing is nearly finished. All the physical features are well defined. Texture has been added to the hair and the flesh. Besides the flat-topped head and broad forehead, the classic Boris Karloff version of the monster featured a slightly triangular indentation between the cheek and corner of the mouth, which gives the creature a unique character. I have also added some shading all around.

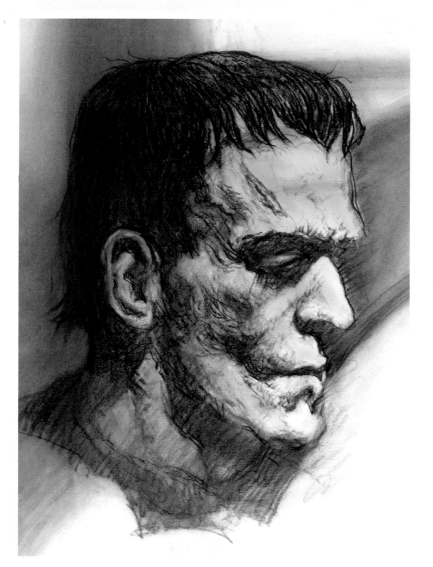

STEP 5: As I said, the prior stage might be enough for some people, but this is where we can really add the dramatic touches that mean so much to monster art. One of the reasons I prefer charcoal is for its ability to smudge and smear. Some may shy away from charcoal for the same reasons, but you can purposely smudge it with a variety of items, including cotton balls and a paper tissue. Large swipes with tissue create a moody background, while softer swipes to the face give it an overall flesh tone.

STEP 6: At right is the finished piece. The finishing touch—following the shading and smudging I added in the previous stage—is to add highlights. This can be achieved in various ways that both add media onto the existing work and take away from existing tone. A soft, pliable kneaded eraser can easily and subtly remove dry media whether pencil, Conté crayon, pastel, or, in this case, charcoal. The kneaded eraser can remove varying degrees of tone, giving us a lot of subtle options. You can see here, in the background tone (bottom left), how I have pulled out the lights—likewise in the neck and face.

 The next option, for sharper highlights, is to paint in with white. You can use opaque whiteout, acrylic paint, Designers Gouache, even animator's cell vinyl. There are touches of white in the face and highlights in the hair, and I added the characteristic metal nodule to the monster's neck with white. This is a classic treatment, which has pleased my fans for years. In the end, between variety of line, the texture of the paper, drawn texture, moody shadows and smudged tones, and finished with the highlights—both lifted off and painted on—we build up a depth and believability that has the credibility of a work of art. The final touch is the signature.

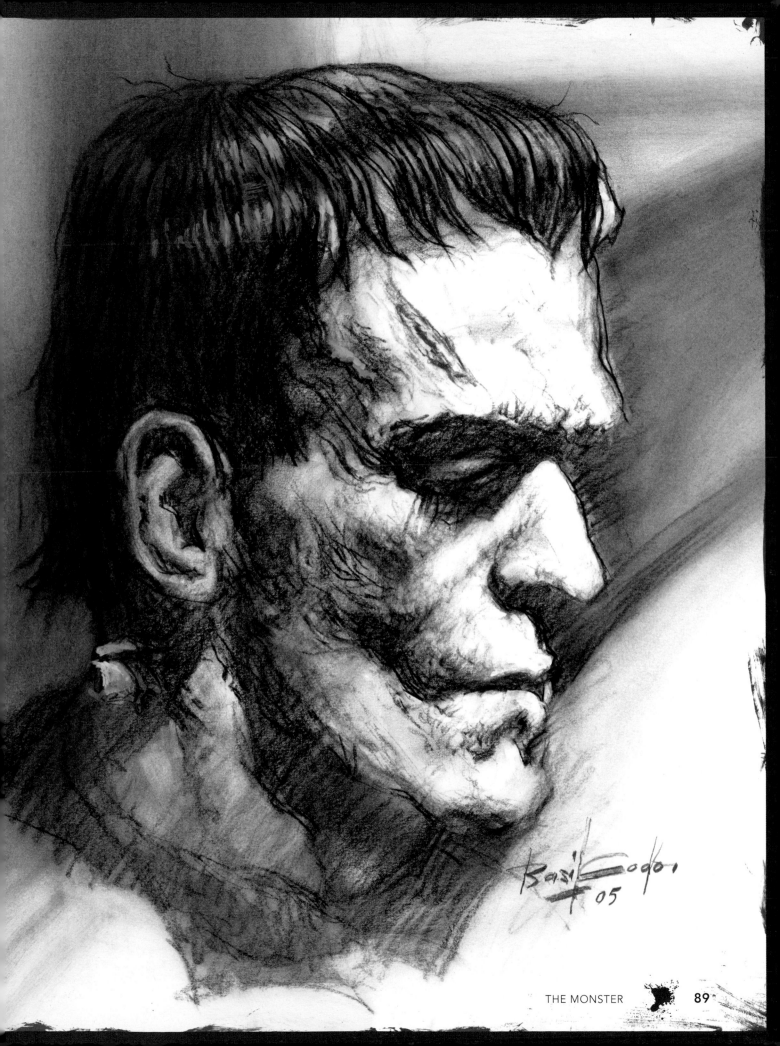

JACK DAVIS

THE ORIGINAL MASTER OF BIGFOOT HORROR

Jack Davis is one of the most popular, beloved, and successful cartoonist-illustrators of all time. His awards include the National Cartoonists Society Milton Caniff Lifetime Achievement Award in 1996, the National Cartoonist Society Advertising Award for 1980, and the National Cartoonist Society Reuben Award for 2000, and he was inducted into the Comic Book Hall of Fame in 2003 and the Society of Illustrators Hall of Fame in 2005. In June 2002, Davis had a retrospective exhibition of his work at the Society of Illustrators in New York.

Davis created a record thirty-six covers for *Time* magazine, as well as myriad other cartoon illustrations for magazines such as *TV Guide*, *Sports Illustrated*, *Playboy*, and *Esquire*, in addition to countless trading cards, record albums, postage stamps, and movie posters, including *Get Smart*, *The Bad News Bears*, Woody Allen's *Bananas*, *Kelly's Heroes*, *Inspector Clouseau*, and *It's a Mad, Mad, Mad, Mad World*. Davis drew the animated bug that screamed "Raid!" in the TV insecticide commercials along with other animated commercials for Alka Seltzer, Gillette razors, Lectric Shave, Ruffles, the Pennsylvania Lottery, Sominex, and others.

But like his contemporary Wally Wood, this legendary talent, Southern gentleman, nice guy, and University of Georgia Bulldogs booster, first gained acclaim drawing for EC Comics: Davis was the lead artist drawing the Crypt Keeper, maniacal mayhem, and more in EC's notorious 1950s horror comic *Tales from the Crypt*. Horror fans have never lost their love for Davis's unique bigfoot horror and followed the artist to his Topps cards (including 1959's *Funny Monsters* set), *Creepy* magazine work, record albums, decades-long tenure at *MAD* Magazine, and more.

Although speed-demon Davis, who is famous for being as fast as he is good, can draw anything, alive or dead, horror fans have noted a definite Davis affinity for the Frankenstein monster.

Jack Davis, courtesy of the artist.

Tales From The Crypt #34 (EC Comics, 1953), cover art by Jack Davis. © WMG

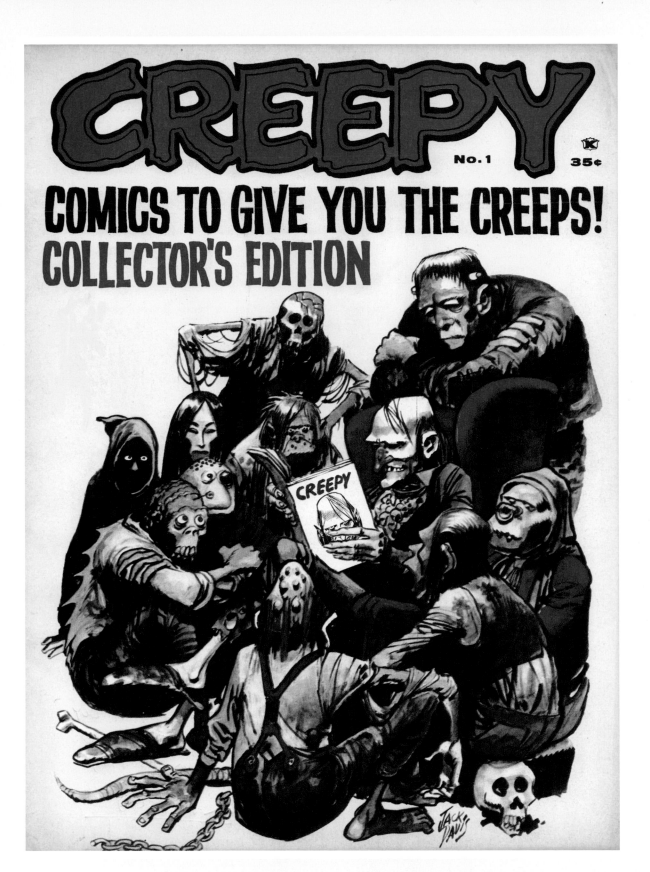

The landmark premiere issue of *Creepy* magazine (Warren, late 1964), cover art by Jack Davis.

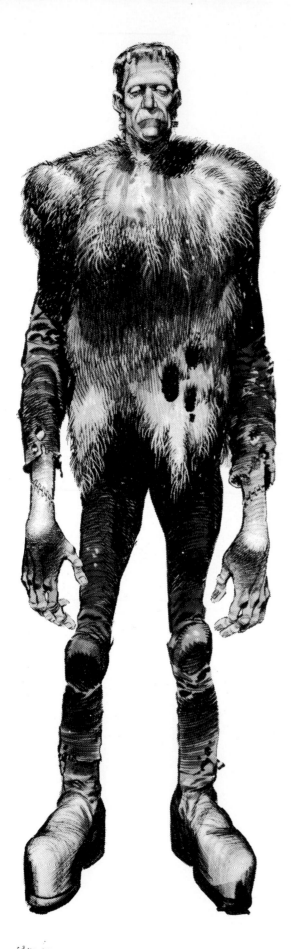

This piece can be called both legendary and beloved by monster fans dating all the way back to the early 1960s, which was a very important time for a large generation of baby-boomer monster kids. It is a Jack Davis drawing of the Frankenstein monster, which sold through various horror magazines as a life-size, six-foot-tall poster, perfect for the back of any monster kid's bedroom door. Parents walk in, no monster, close the door, and it's you and your favorite village ransacker stitched together from spare cadaver parts! *Yes!* What could be better?

Davis used great technique here—beautiful cross-hatching on the fur jacket. Hey, nice stitching on the wrists, too. Davis imbues Franky with a unique presence and body language.

THE MONSTER

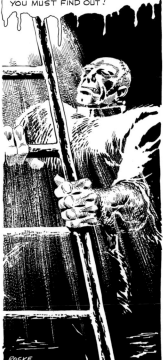

YOU ARE SICK OF THE DARKNESS, TIRED OF THE MOSS AND SLIME-COATED WALLS.... YOU CAN TAKE NO MORE OF THE DARK MURKY WATER AND MUSTY CHILL... YOU MUST MOVE, ACT....

WHY ARE YOU HERE IN THIS PLACE OF DANK AND BLACKNESS? THE REASON IS NO LONGER CLEAR...BUT YOU'VE GROWN TIRED OF IT... SOMETHING IS URGING YOU ON... TOWARD THE LIGHT...

YOUR HAND CLOSES ON THE RUST-COATED RUNG... YOU EXPERIENCE A SENSE OF FORBODING... WHAT WAITS ABOVE? ONCE YOU KNEW, BUT NOW YOU'RE NOT SURE... YOU MUST FIND OUT!

ROCKE

At left, we have a nice sewer sequence with our favorite Frankenstein monster as drawn by Rocke Mastroserio from *Creepy* #10. Rocke uses a unique ink technique to communicate texture on every substance in this work: He uses an X-Acto knife to scratch off highlights for the light shining down from above.

Below is a masterful, detailed monster illustration by Bernie Wrightson. The monster comes back from the grave with his creator in mind.

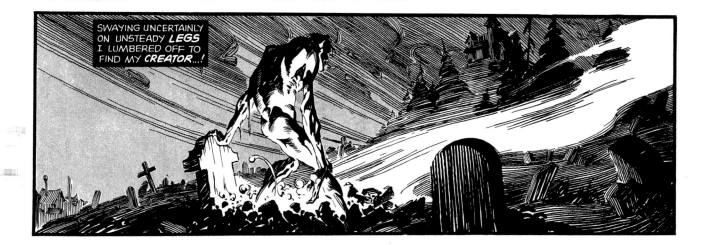

SWAYING UNCERTAINLY ON UNSTEADY *LEGS* I LUMBERED OFF TO FIND MY *CREATOR*...!

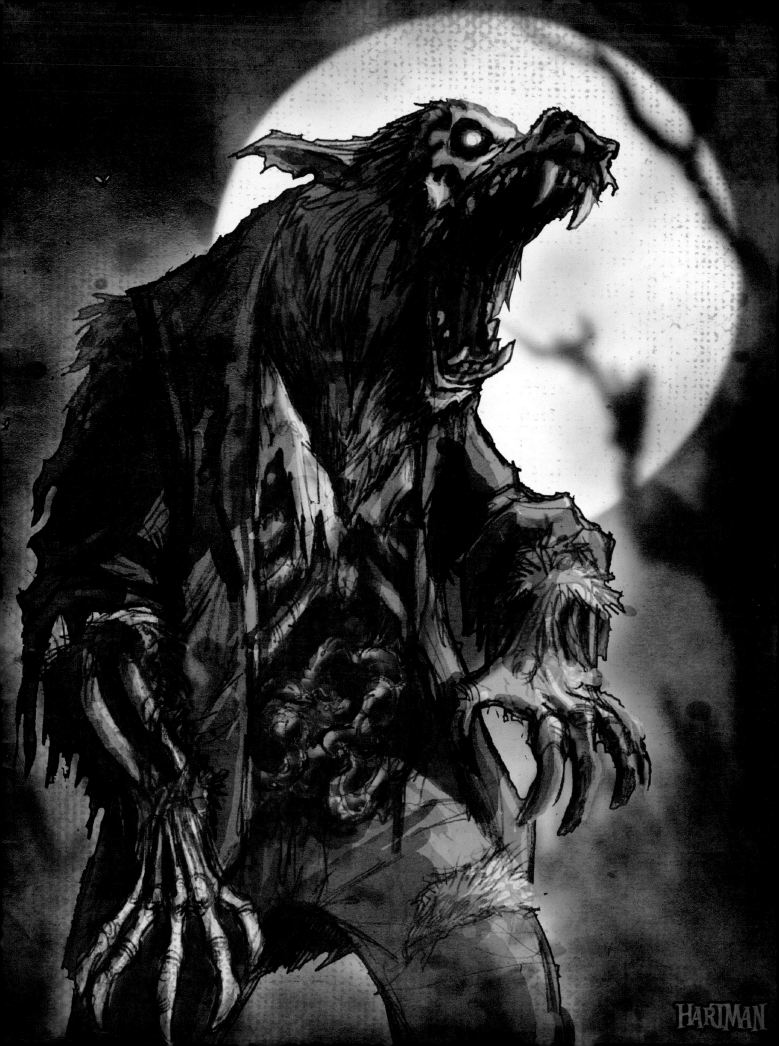

WEREWOLVES
Drawing Moonlight Mayhem to Howling Effect

Howling he fled, and fain he wou'd have spoke;
But humane voice his brutal tongue forsook.
About his lips the gather'd foam he churns,
And, breathing slaughters, still with rage he burns,
But on the bleating flock his fury turns.
His mantle, now his hide, with rugged hairs
Cleaves to his back; a famish'd face he bears;
His arms descend, his shoulders sink away
To multiply his legs for chase of prey.
He grows a wolf, his hoariness remains,
And the same rage in other members reigns.
His eyes still sparkle in a narr'wer space:
His jaws retain the grin, and violence of his face.

—OVID
Metamorphoses, AD 8

Growling, howling, gnashing teeth; flesh and bone-ripping claws; breath like the worst dog's ever combined with the stench of rotting flesh— generally, werewolves are not nice company to keep. But, you know, if you woke up in the morning, every month, after a full moon to find you just ruined another pair of new shoes, slacks, and shirt, you'd be howling mad, too. Depending on the company you kept the night before, you might even wake up with fleas, with no one to blame but yourself. Try explaining that to the wife.

Werewolves are known to howl at the moon. Get ripped open like this werewolf by David Hartman and you would be howling too. Just try to imagine the beast that could do this kind of damage to a werewolf!

A BRIEF HISTORY OF WEREWOLVES

A werewolf, or werwolf (or lycanthrope, from the Greek), is a human with the ability to change into a wolflike creature. This is brought on from either being placed under a curse or being bitten by another werewolf. As recorded by the medieval chronicler Gervase of Tilbury, and in earlier times among the ancient Greeks and Romans through the writings of Petronius, the transformation frequently coincides with the appearance of the full moon. Werewolves often have superhuman strength and senses, far beyond those of wolves and men. The werewolf is best known in and seems to have hailed from Europe, although its lore has spread through the world.

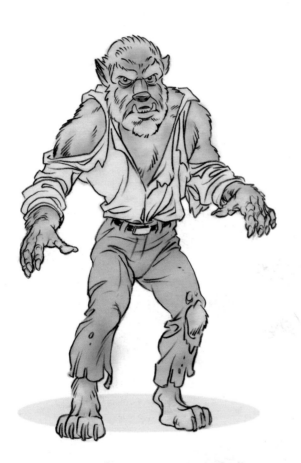

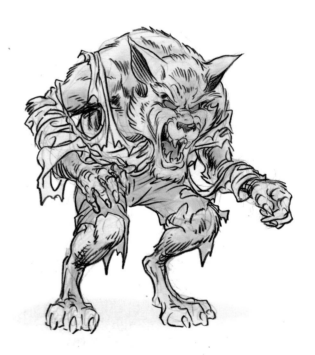

Manlike werewolves walk a bit more upright and have human-like legs, with the exception of clawed, pawlike feet. These types were popular in werewolf films from 1913 through the 1960s, including Universal's *The Wolf Man* (1941), starring Lon Chaney Jr.; the 1961 Hammer film *Curse of the Werewolf*, starring Oliver Reed; and 1957's *I Was a Teenage Werewolf*, starring the prolific Michael Landon of *Bonanza*, *Little House on the Prairie*, and *Highway to Heaven* fame. Some later, less effects-oriented films—such as *Teen Wolf*, starring Michael J. Fox; *Thriller*, starring Michael Jackson; and *Wolf*, starring Jack Nicholson—also feature this type.

Wolf-type werewolves are more hunched forward, less upright, have a deeper snout nose, and walk on more wolf-like or canine legs. Examples of this type can be seen in mostly later werewolf films, including the great werewolf film-revival explosion of 1981: *Wolfen*, *The Howling*, and *An American Werewolf in London*. *The Howling* featured makeup effects by Rob Bottin, a protégé of Rick Baker, who created what most agree are the greatest werewolf film transformation scenes ever, in *An American Werewolf in London*. More recent films featuring this type include *Van Helsing* and the *Underworld* series.

Fictional accounts in the last hundred years or so attributed some traits other than those of traditional accounts, most notably vulnerability to silver bullets. We recommend that if you hunt werewolves, for life drawing or other purposes, you don't risk your life solely upon faith in silver bullets.

Werewolves can generally be split into two groups: those that look more like a man, and those that look more like a wolf. (Illustrations by Pat Binder and J. David Spurlock.)

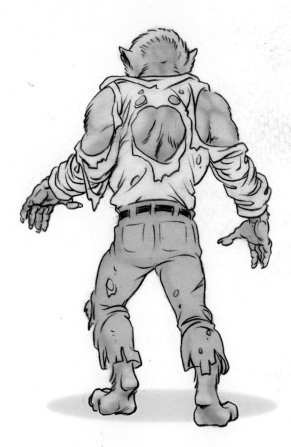

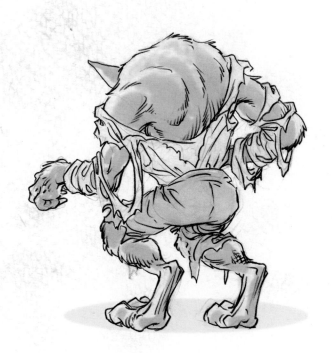

Here are rear versions of the two primary werewolf types. It is very important to be able to draw your monsters from all sides. As getting a good look at monsters in the wild is hard to do without getting your head torn off or jugular vein ripped into, you must be able to reconstruct monsters from memory and/or imagination. These drawings were done just that way—from memory and imagination—saving our jugular vein for another day. These types of front, back, and even side drawings are known as *turnarounds* and are often used in the designing of toys, statues, mannequins, and promotional giveaways (also known as *premiums*). There is work to be had doing such drawings.

These drawings were done in pencil, but some tone and color was added digitally. This is a common technique, and various computer programs can be incorporated, but the most common is Photoshop. Whether you're doing your tones and color in traditional media like watercolor or colored pencil or digitally, the goals are the same: to add form, structure, texture, and, in these cases, a bit of monstrous mood or atmosphere. Always keep in mind what your light source is—moonlight, gunfire, torches from the villagers, or otherwise.

ALEX HORLEY

BREATHES NEW LIFE INTO GRIZZLED MONSTERS

Born Alessandro Orlandelli in 1970 on the outskirts of Milan, Italy, Alex Horley's love for the fantastic came early while reading his favorite comic books, which he started to learn to draw while he was still in kindergarten. Years later, it was the writings of Conan creator Robert E. Howard and the art of Frank Frazetta that fueled his imagination and inspired his passion for the fantasy art genre.

Horley was accepted into the prestigious Academy of Fine Arts in Milan. Though he spent his days studying the works of the Italian fine art masters, he never lost his love for the fantastic and began painting his own fantasy illustrations, launching his career as a professional illustrator upon graduation from the Academy.

His work has since expanded into a wide variety of markets and has been receiving rave reviews from around the world. Horley has become best known for his provocative and dynamic painted illustrations for the World of Warcraft trading card game, *Magic: The Gathering*, *Heavy Metal* magazine, and the Versus trading card game featuring the characters from Marvel and DC Comics. His versatile techniques have earned him the reputation of one of today's top creative visionaries, and he is finding an ever-expanding audience. In the recent *Alex Horley Sketchbook* (Vanguard), Rock star and horror film director Rob Zombie said, "Alex Horley's art jumps off the page, grabs you by the throat, and smashes your head against the wall until you beg for mercy. Complete mind-numbing artistic devastation!"

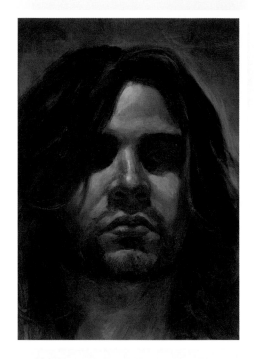

Alex Horley, courtesy of the artist.

The recent *Alex Horley Sketchbook* from Vanguard collects a wealth of the artist's best work.

DEMONSTRATION: THE WEREWOLF

STEP 1. This first stage is where the composition's elements are assembled, the main shapes of foreground and background are suggested, and the pose is nailed down with little more than a stick figure.

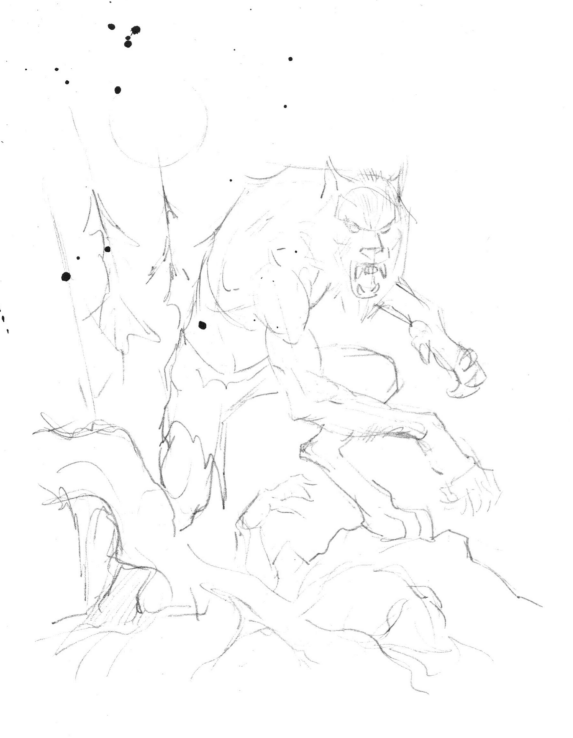

STEP 2. Here the basic outline and face elements are established. A little bit of anatomy is also starting to build up. I wanted the werewolf to be muscular but still lean, to remind the viewer of a drawing of an actual wolf's body structure.

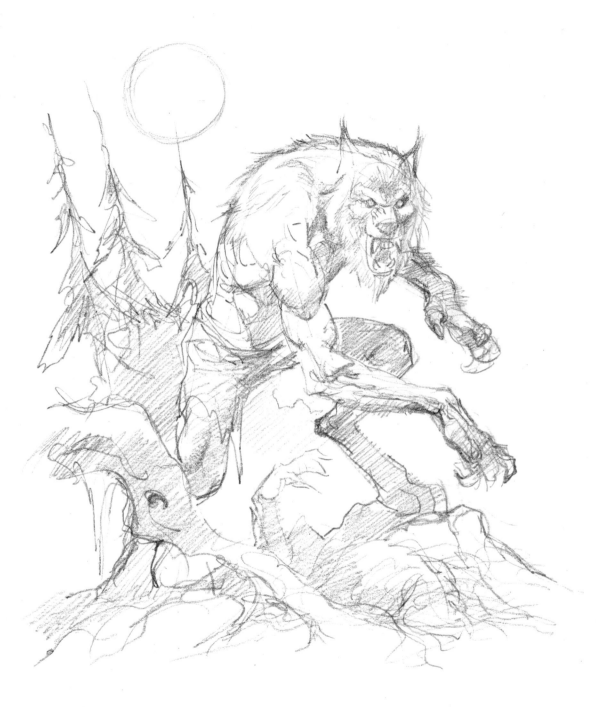

STEP 3. The next step is to start filling the shadow areas and begin to add volume to the layout. More details are added to the figure and the face, where I want the focus.

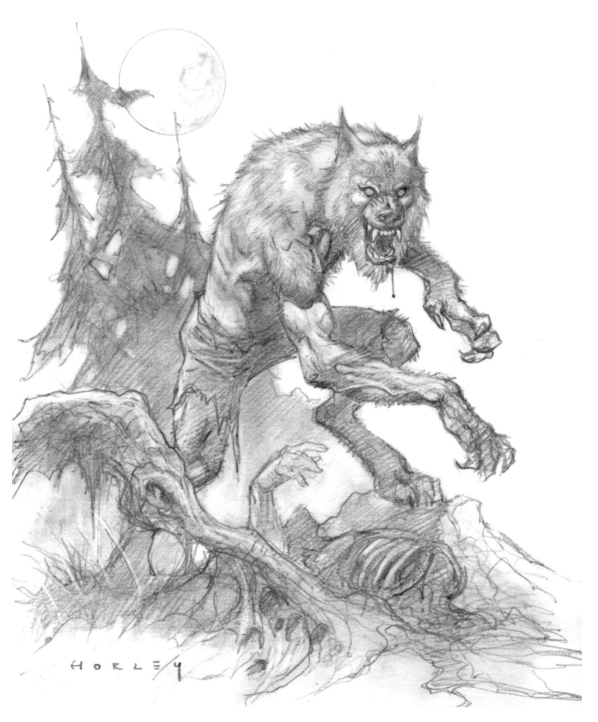

HORLEY

STEP 4. This is where all the drawing's element are finalized and contrast is balanced. I deliberately left some areas more rough than others. As I usually do for my paintings as well, I put more work and detail in the areas that I want the eye to focus on (in this case, head and upper body). This also allows the art to keep some freshness and energy, which would be lost if the drawing were evenly rendered overall.

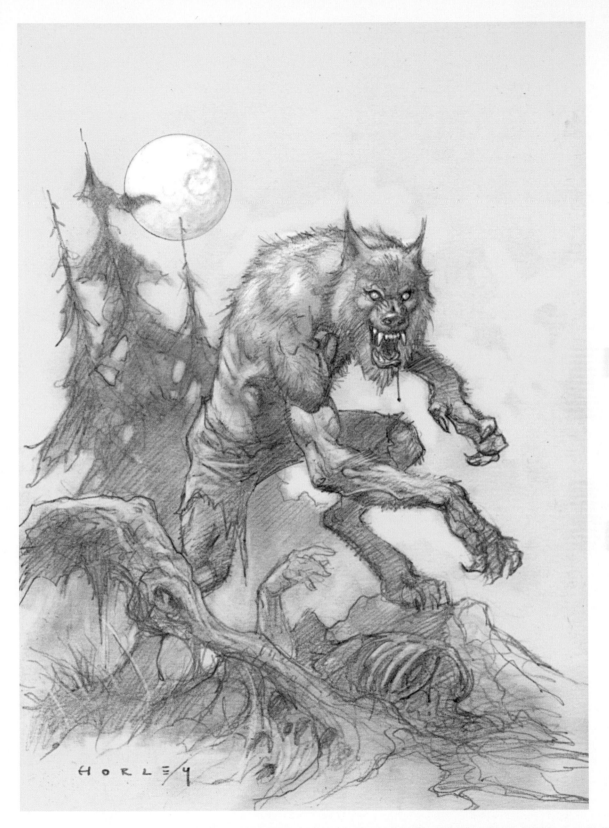

STEP 5. This "extra" step was done digitally. I simply added one layer and left a light gray tone over the whole drawing. Then I used the eraser tool to emphasize a bit the highlights and some details like the eyes, fangs, and the moon.

KERRY GAMMILL

Kerry Gammill, courtesy of the artist.

THE KING OF HOLLYWOOD MONSTER DESIGNERS

After a noteworthy career drawing Superman, Indiana Jones, Deadly Foes of Spider-Man, etc., the comic book work of artist Kerry Gammill mysteriously disappeared from the pages of *Superman* and *X-Men* a few years ago. While illustrating mainstream superhero comics had been the artist's childhood dream, the artist's book, *Drawing Monsters & Heroes for Film & Comics*, revealed Gammill's mysterious exodus was to fulfill another lifelong desire—to work on monster films.

In the years since, Gammill's name, while missed from the pages of America's foremost comic books, has become familiar to Hollywood. Gammill has risen to work as a conceptual artist on top film and television projects including Stephen King's *Storm of the Century* TV miniseries, *Virus*, *Species II*, *Can of Worms* (TV, 1999), Dean Koontz's *Phantoms*, the *Stargate SG-1* TV series, and *The Outer Limits* TV series.

The job of film conceptual artist is essential, exciting, lucrative, and little understood. In *Drawing Monsters & Heroes for Film & Comics*, Gammill took us behind the scenes on the very important but little-known world of film conceptual art with a focus on designing creatures for action films. Since then, Kerry and I produced the Rondo Award–winning hit *Famous Monster Movie Art of Basil Gogos*, and Kerry has just finished a cover for *Famous Monsters of Filmland* magazine.

Here, and on the next few pages, we see an assortment of werewolves by Kerry Gammill. Both Kerry's experience as a Hollywood monster designer and his great affection for classic monster films are apparent in these works. Be sure to check out Kerry's online monster magazine: www.monsterkid.com.

Kerry Gammill's book on his career in film and comics art.

HOLLYWOOD WEREWOLF DRAWINGS BY KERRY GAMMILL

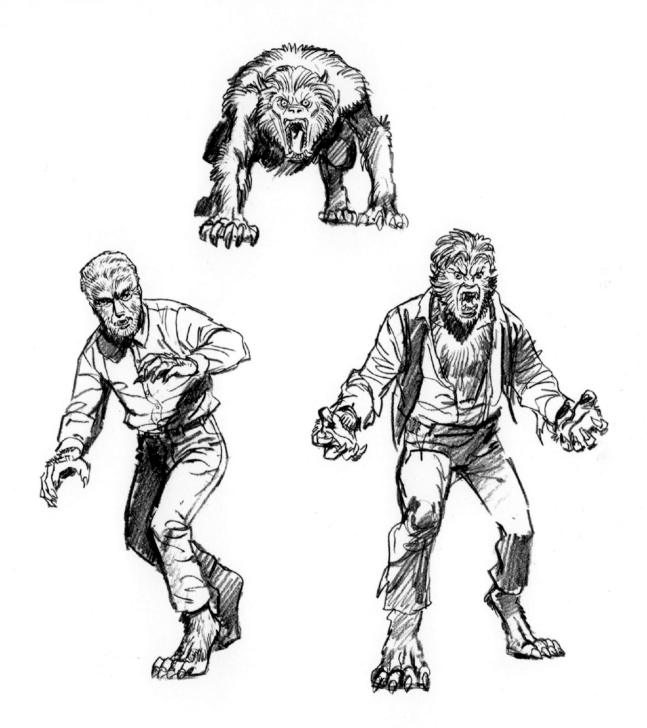

Here are Kerry's takes on the basic varieties of werewolves. He has given us two examples of traditional wolfman types, and his manwolf type is about as wolfish as a werewolf gets—actually on all fours. This most-wolflike werewolf is similar to those in the series of *Underworld* films and in Neal Adams's graphic novel *Neal Adams Monsters*.

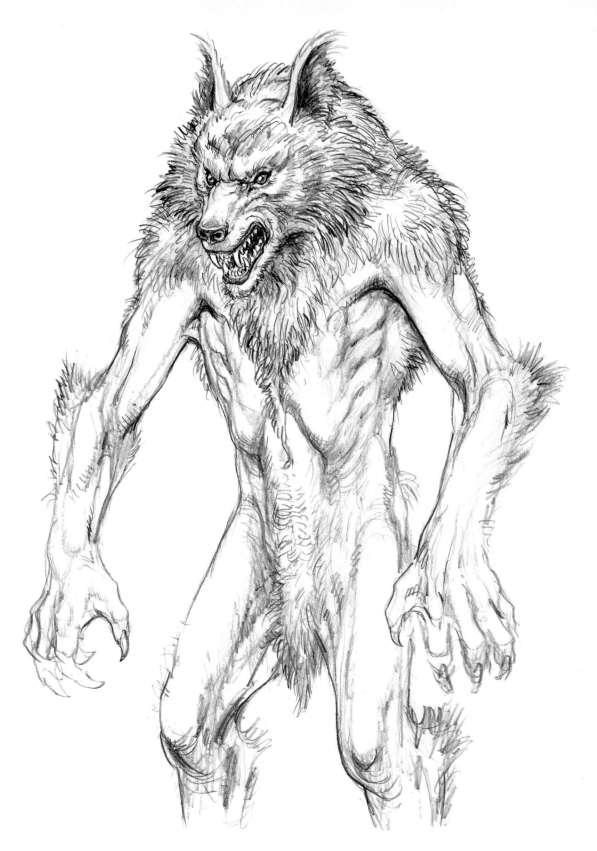

A werewolf design for film by Kerry Gammill. Here we see the drawing in progress, in pencil.

WEREWOLVES

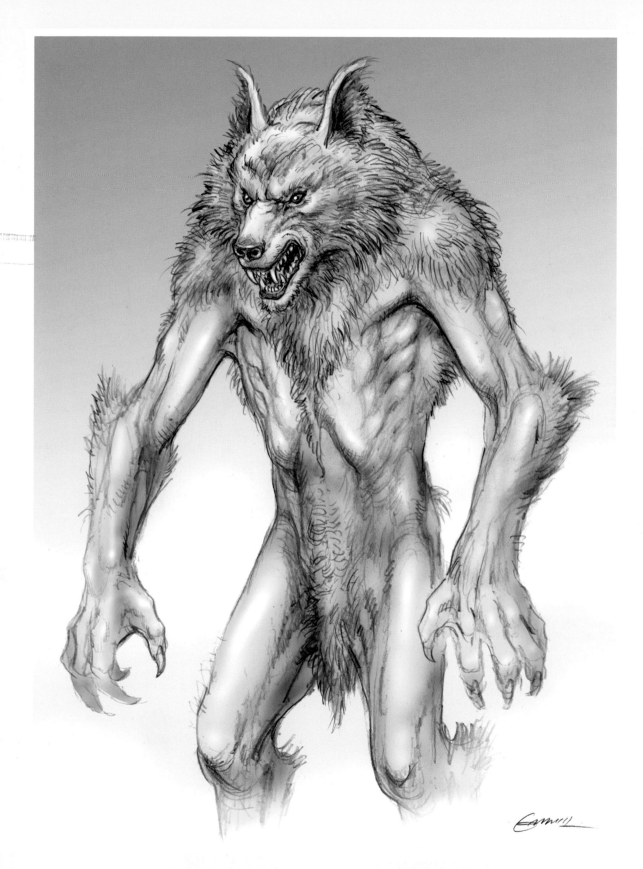

Kerry finishes his werewolf design for film by rendering with tonal effects.

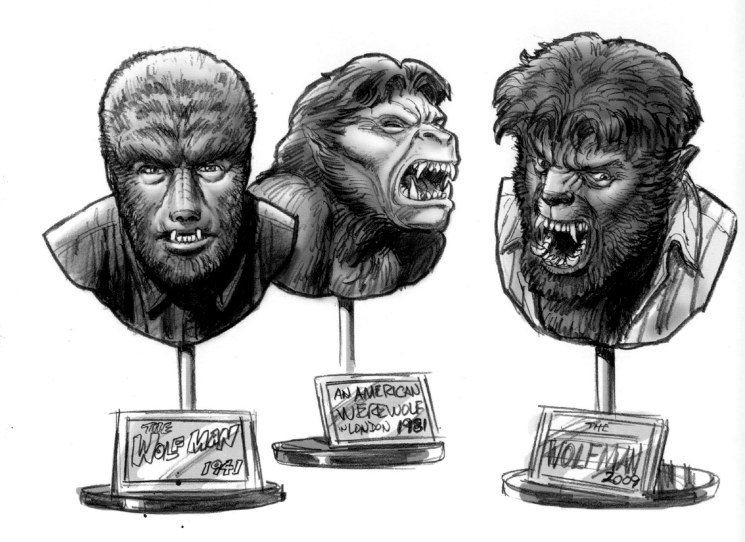

Here you see Kerry's bust designs for the *Wolf Man* (1941, left), *An American Werewolf in London* (1981, center), and *The Wolfman* (2009/2010, right). Kerry's addition of tones to the pencil drawings adds dimension, texture, and highlights to the drawings—all very important in communicating depth for your deadly creatures.

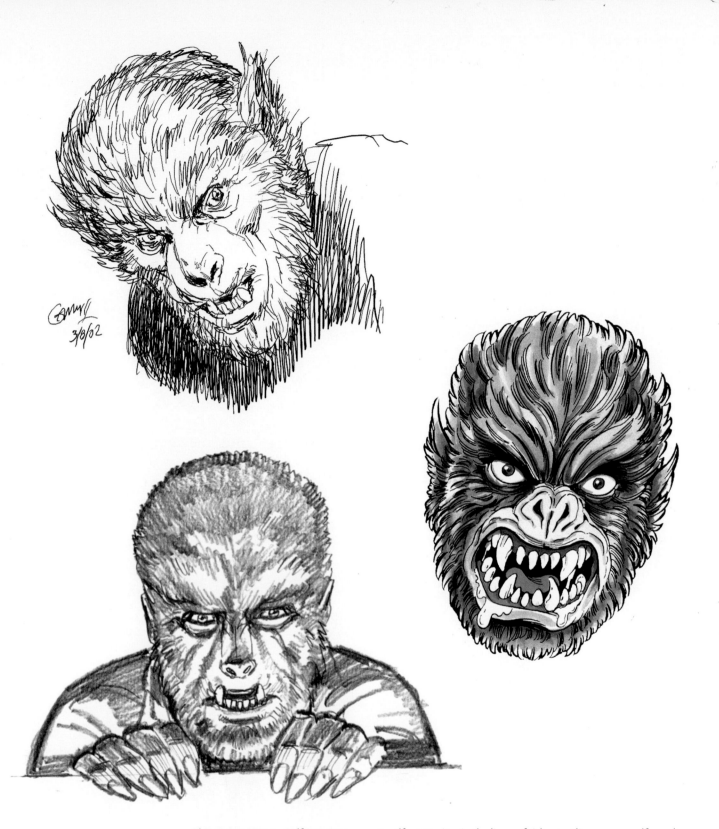

Above are more wolfman-type werewolf portraits, including a fairly startling werewolf mask design (at right). Designing costuming is another way one can draw monsters professionally. The mask itself could be used for costume parties, trick-or-treating on Halloween, or as a disguise, in hopes of getting closer to your subjects when drawing monsters in the field.

COMPOSITION
Designing Monstrous Groupings

The Devil dropped dead and the werewolf fled,
—Eerily, wind, sing eerily—
And the vampire waggled his ghastly head.
And the wind was blowing eerily.
Eerily, eerily, blow, wind, blow,
With a heave and a hey, so eerily.
With a heave and a hey, so eerily.

—ROBERT E. HOWARD
"Weird Ballad," 1932

To *compose* means to arrange or put together in a calculated or planned manner all the elements (components) in an artwork. It is the arrangement or placement of artwork's elements, subjects, or figures in any given piece, according to the principles of art, design, and layout.

Some of the principles of art, design, and layout that factor into composition include perspective, viewpoint, shape and proportion, orientation, cropping, harmony, negative space, balance, color, lighting, and rhythm (including repetition and pattern). Three other major areas of interest are contrast, path of the viewer's eye, and compositional geometry.

This drawing is by artist Neil Vokes from his
World War I–era gothic novel *Black Forest*,
with writers Tinnell and Todd Livingston.

THE COMPONENTS OF COMPOSITION

Here are the essential components of composition to keep in mind as you plan your drawings.

Perspective: Creating a sense of depth (receding space) to make two-dimensional drawings look three-dimensional by varying the sizes of the artwork's components. Those closer to you are larger and in the foreground; those farther from you are smaller and in the background.

Viewpoint: The position or angle from which the composition is viewed (from above, below, inside, outside, etc.).

Shape: The length and width of a drawing component.

Proportion: The relationship among components of a drawing with respect to size or quantity.

Orientation: Similar to viewpoint, but orientation also has to do with how components relate to each other within a composition.

Cropping: To trim an artwork to highlight a part of it.

Harmony: A blend of compatible components in the artwork to accent their similarities.

Negative space: Empty space in an artwork.

Balance: Arranging the components of the artwork in a harmonious way to create stability in the drawing. Balance can be achieved through symmetrical or asymmetrical arrangements.

Color: Hue, saturation, and brightness all affect mood and composition.

Lighting: The amount of light and dark in an artwork, and the direction from which that light comes.

Rhythm and pattern: Repetition of components and color, line, and form in the artwork.

COMPOSITIONAL RELATIONSHIPS

My primary theme when discussing composition and design is *relationships*. When designing a composition, consider specifically how each element relates to the others. All visual relationships can be broken into two categories: *contrasts* and *similarities*.

You can create great depth of visual relationships by using contrast and similarities in your composition. One object can be bigger than another (contrast), but those same two objects might be the same shape (similarity). The same objects might be different colors (contrast) yet have the same orientation (similarity).

Contrast, in general, is the degree of lightness and darkness in a subject, most often as it relates to another subject. But you can have all types of contrasts (and similarities), including size, shape, proportion, color, placement, balance, etc. The more you think about and plan how your components relate in terms of contrasts and similarities, the greater the depth of relationship is and the better the composition is.

CENTER OF INTEREST

Decide what the center of interest (key subject) will be in your piece and compose the other elements in relationship to that key subject. Arrange the elements to be harmonious and unified—yes, even when the subjects are ripping each other apart. Breaking the harmony creates unease in the viewer. On rare occasions, you might choose to do that purposely, but if you do cross that bridge, do it cautiously and with specific planning.

PATH OF THE VIEWER'S EYE

The path or direction followed by the viewer's eye when observing the image must be considered in every piece. Plan where the viewer's attention will enter the composition (key subject) and where it travels from there. Shun what award-winning illustrator Barron Storey refers to as an *eye trap*: "Eye trap occurs when the composition has areas that tend to freeze movement without reason or 'payoff' for that static condition." Squarish areas tend to cause eye trap. Right angles at the image crop take viewers out of the scene, causing their attention to stagnate on the surface of the paper.

COMPOSITIONAL GEOMETRY

The Golden Mean is an aid to composition, a ratio used by artists for centuries. Dividing the parts of an image according to this ratio helps to create a pleasing, balanced composition. Two elements are in the golden mean ratio when the *sum* of the two elements (A + B) to the larger element (A) is equal to the *ratio* of the larger element (A) to the smaller element (B). In other words, A + B is to A as A is to B. (This ratio is 1 to 1.618, or 3/8 to 5/8.)

The rule of thirds is a simplification of the golden mean. Divide the total area of your artwork by drawing a grid that divides it into three equal columns and rows. The objective is to place elements in your composition near one of the grid lines, ideally near the intersection of two lines.

I have simplified this method even further for my students by naming it the Tic-Tac-Toe method of design. Imagine drawing a tic-tac-toe grid over the drawing space. Then place your elements in relationship to the grid lines. See?—as simple as tic-tac-toe.

a+b is to a as a is to b

thirds/tic-tac-toe grid

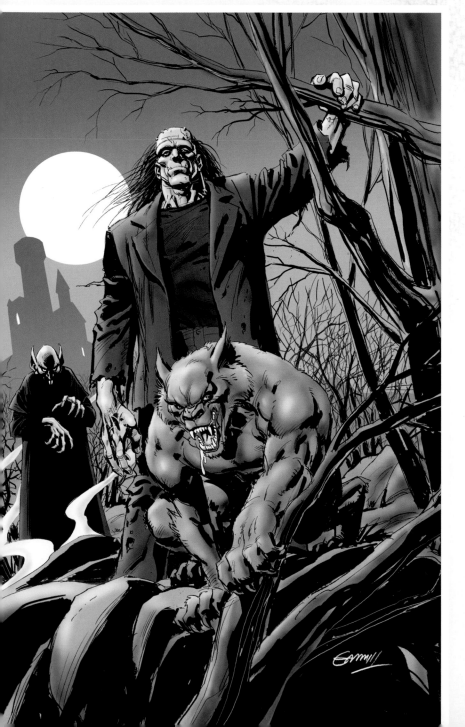

Here we have a composition by Kerry Gammill featuring a vampire, a werewolf, and the Frankenstein monster. Kerry leads our eye along the left tree to the vampire, up through the castle to the moon, over to Franky, down to Wolfy, into the tree branch, and up along the large tree, to exit top right. From there our eye is actually tempted to circle left to take the trip again. This is a very successful composition, with the moon playing a major role in tying the piece together—especially by having both the castle and Frank just breaking its outline.

JIM STERANKO

THE GRAPHIC PRINCE OF DARKNESS

As an illustrator, musician, art director, magician, designer, escape artist, filmmaker, pop-culture lecturer, and publisher, Steranko has cut a ferocious path through the entertainment arts. The more than one hundred innovations he created as artist-writer on Marvel's *S.H.I.E.L.D.*, *X-Men*, and *Captain America* revolutionized the comics genre. As an illustrator, he painted a multitude of book covers, including thirty *Shadow* paperbacks.

Known as the Graphic Prince of Darkness, Steranko has shown his work at more than two hundred exhibitions worldwide, including the Louvre in Paris and the Smithsonian Institution in Washington, D.C. His two volumes of *The History of Comics* have sold more than 100,000 copies, and as editor-publisher of the international entertainment magazine *Prevue*, he conducted hundreds of star interviews and penned more than 3 million words. As a filmmaker, he has collaborated with Steven Spielberg, George Lucas, and Francis Ford Coppola on some of their most popular movies, including *Raiders of the Lost Ark* and Coppola's *Bram Stoker's Dracula*.

Steranko has been cited by Michael Chabon as an inspiration for his Pulitzer Prize–winning novel *The Amazing Adventures of Kavalier and Clay*, by Jack Kirby as inspiration for Mister Miracle, and by *Wizard* magazine as one of their Top Five Most Influential Comic Book Artists of All Time. Recent projects include *Domino Lady: The Complete Collection* (Vanguard), the Discovery Channel's *Comic Book Superheroes Unmasked* documentary, the *2007 Steranko Calendar-Portfolio* (Vanguard), STARZ network's *Comic Books Unbound*, writing an episode of Cartoon Network's *Justice League* series, cover paintings for the new *Planet of the Apes* novel, *The Spider* book covers, and various Hercules pieces for Radical Publishing. The Eisner Award Hall of Fame artist-writer contributes here an original essay on composition and color, beginning on page 116.

Jim Steranko picks up the Julie/Man of Two Worlds Award at the Atlanta Dragon*Con, in 2003. Courtesy of the artist.

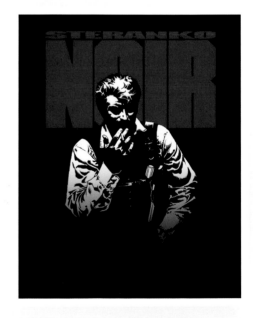

Steranko Noir cover (Vanguard/Semana Negra, 2002).

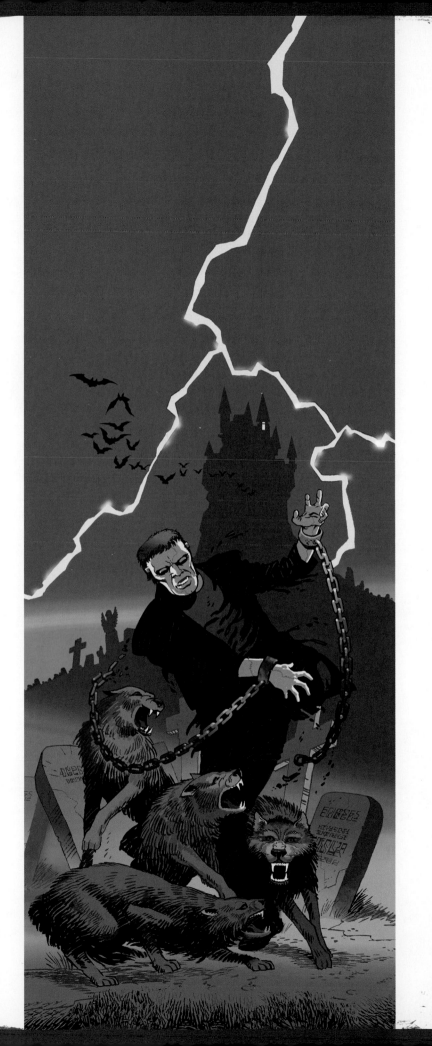

Comic protector box design by Steranko (Supergraphics, 1973).

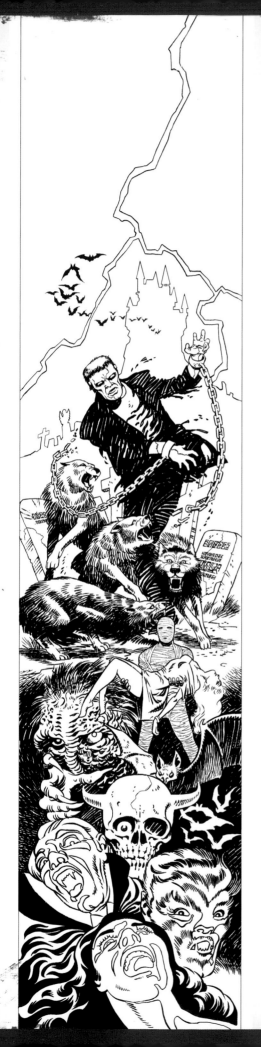

PANEL 1 (left): This is the original black-and-white brush-and-ink illustration.

"Whether a project is a billboard or a panel on a box, the aspect of strong design is always foremost in the development process. The box, in this case, is a protective pressed-board sleeve that houses twenty-four comic books and decoratively visualizes a quartet of themes, one on each of four sides: superhero, sword and sorcery, jungle girl, and monsters.

Opting for the classic elements—vampire, werewolf, living skull, gargoyle, mummy, terrified woman, bats, castle, graveyard, and Frankenstein—I chose the latter around which to build the panel (see left), positioning the rampaging figure's head a third down from the top edge. The plane on which the action occurs is roughly defined by the division of the second third, where the edge drops into blackness. Thirds are easily discerned by the human eye—a subconscious observation that creates a sense of spatial comfort and order in the viewer's psyche.

Although the Frankenstein figure is centrally placed, the twisting torso and three-point configuration of the head and hands not only counteract the stiff, symmetrical quality the image could have but import a sense of motion to the scene. That characteristic is also enhanced by the erratic flight of bats, the swinging chains, and the position of the wolves, particularly the surrounding trio, which have a kind of animated, three-beat effect. The surging angularity of the electrical bolt further heightens the movement of the scene.

Initially attracted by the powerful, spiral composition, which begins with the downward lightning thrust, the viewer's eye then moves to the head of the figure and continues down the shoulder to the wolves. The sweep of the castle outline in the background also helps to urge the eye downward. Next, the left-to-right motion of the animals leads the eye to cross the image at its base and ascend, aided by the upturned muzzle of the middle wolf, the silhouette of the figure, and the swirl of chains. The placement and angles of the headstones also facilitate a circular eye movement. Finally, the eye drifts back to the head and bright shirt area and is pulled downward by the funnel-like silhouette of the figure—and crosses into the lower area, helped by the position of the mummy, which serves as an entrance to the bottom third of the panel."

PANEL 1 (left): This is the original black-and-white brush-and-ink illustration.

PANEL 2 (near right): **Prismatic variation** uses a full range of color, but is essentially built on the triadic harmony of purple, green, and orange. Additional colors are used sparingly, in small areas, for counterpoint interest. Green predominates in the middle third, with purples at the top, and multiple colors at the bottom.

PANEL 3 (far right): **High-key variation** utilizes two warm colors (red, yellow) next to each other on the color wheel to create what is termed analogous harmony. The impression is one of searing heat and arid atmosphere.

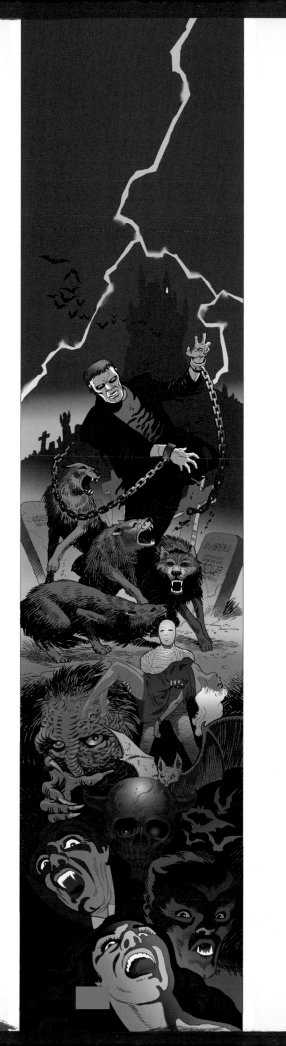
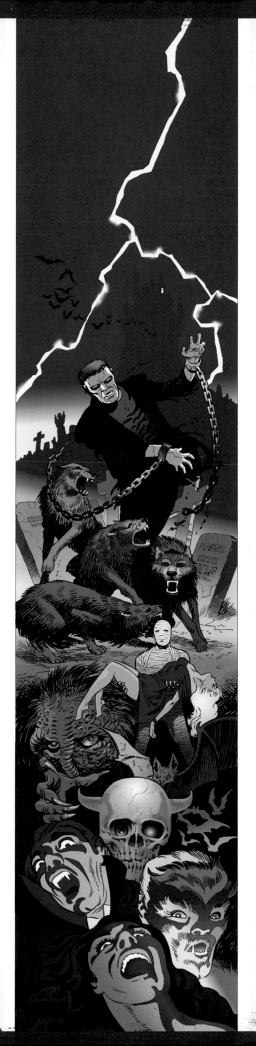

Note how the overlapping elements of the primary image—one wolf over the trio, the trio over the figure, the grouping over the gravestones, the foreground unit over the castle, and the entire ensemble over the ominous sky—create the illusion of deep space, of considerable distance that invests the scene with an epic, three-dimensional quality.

The lower third—visually below ground level and psychologically suggesting a kind of macabre underworld—assembles a host of horror-related heads in a collage-type cluster, grouped to keep the viewer's eye inside the panel and ending with a shrieking woman looking upward into the image.

It's worth noting that, even though the panel has many elements, it reads easily, without confusion. Part of that quality is achieved by the balance of positive (bottom third) and negative (top third) space, which relieves the image from being too cluttered with graphic information.

Another aspect of balance is due to the careful juxtaposition of black and white areas, in addition to a varied ink line and multiple textures, which create further visual equipoise, keeping the art lively and kinetic, without calling much attention to itself and distracting the viewer.

Color is also an element in the architecture of composition, with the factors of hue (basic group), chroma (high to low intensity), and value (bright to dark) each playing important parts in the construction of evocative imagery.

The variations shown in these panels represent a cross-section of possible color concepts, which may suggest starting points for future art projects. All were created digitally in Photoshop.

One last recommendation: Have a good time solving composition and color challenges; it'll show in the finished work! ''

PANEL 4 (far left): **Low-key variation** uses a similar analogous approach but with cool colors (blue, green). The impression, although reasonably vivid, is one of darkness and nocturnal desolation.

PANEL 5 (near left): **Chiaroscuro variation** uses a monochromatic harmony derived from a single color but with a variety of values and chroma intensities for considerable atmospheric effect. Another color (orange) was added to the lightning bolt for a minor surprise.

PANEL 6 (right): **Polychromatic variation** parlays a split-complementary harmony (green, orange, and violet) into a vista of limited but striking color. The greens have very low chroma and play dramatically against the high chroma of the oranges, which are used with very limited application. Most of the colors are grayed down to achieve unified harmony.

HARD-LINING IT
The Black of Night in Your Inkwell

Howling he fled, and fain he wou'd have spoke;
But humane voice his brutal tongue forsook.
About his lips the gather'd foam he churns,
And, breathing slaughters, still with rage he burns,
But on the bleating flock his fury turns.
His mantle, now his hide, with rugged hairs
Cleaves to his back;
A famish'd face he bears;
His arms descend, his shoulders sink away
To multiply his legs for chase of prey.
He grows a wolf,
His hoariness remains,
And the same rage in other members reigns.
His eyes still sparkle in a narr'wer space:
His jaws retain the grin,
And violence of his face.

—OVID
Metamorphoses, AD 8

We aren't just talking about night as black as ink; we're talking about ink as black as ink. When your fingers are stained black and calloused from holding both pen and brush, and you mistakenly pick up your India ink instead of your glass to take a drink, then you will begin to properly appreciate the ink slingers of lore.

In this chapter, we'll cover the tools, supplies, and basic strokes of hardlining and work on techniques for inking pencil drawings—yours or another artist's.

Old Nessie has nothing on this sea monster—Bernie Wrightson's masterfully inked *Pepper Lake Monster*.

TOOLS AND SUPPLIES

You don't need a lot of tools and supplies to achieve good results when hard-lining:

- Higgins Black Magic India ink
- Crow-quill and larger dipping pens
- Winsor & Newton red sable watercolor brushes #0, 1, 2, 3, 5
- A set of technical pens (Rapidograph or similar), or at least various sizes of Micron
- Bristol board: kid finish (matte), plate finish (slick), velum (between kid and plate finishes)
- Illustration board: heavier than Bristol board, it comes specified as either hot press (smooth or slick) or cold press (has a lot of texture, similar to watercolor paper)
- Tracing paper: various types, including vellum, which is high quality

Take these tools and practice with them. A good exercise, worth doing every day until you are a working, professional artist, is to take brush, ink, and tracing paper and practice inking over photographs and fashion drawings. What? Fashion drawings? Yes, they have a certain flair that is helpful when learning to master a brush. Be very protective of your brushes and pens. Guard them and protect them as you would your wooden stakes and silver bullets! Keep them clean. Never leave them point down in a jar of ink, water, or otherwise. When you buy a brush, make sure you get the clear plastic protector that is supposed to come with it.

BASIC PEN AND BRUSHSTROKES

Here are the basic pen and brushstrokes you'll need to master for successful inking.

When using brushes, I recommend you turn your brush. As you draw a brushstroke, roll the brush slightly between your fingers. This can add some flair to the stroke, and it helps to cultivate and maintain your brush point, which is very important.

A sphere in four different ink renderings, from left: horizontal lines, crosshatching, stippling, and radiating brushstrokes.

Dipping-pen lines, from left: shading lines, slight thinning lines, and two examples of gradation lines.

Ruling with a pen, from left: parallel lines, curved lines (using French curve), and stipple gradation.

Dipping-pen strokes, from left: smooth and regular crosshatching lines and two examples of gradated crosshatching, the last one using three overlapping angles of lines.

Basic brushstrokes, from left: flowing, contour, feathered, and two examples of gradated lines.

INKING PENCIL DRAWINGS

As well as inking your own art for any number of purposes, there is also work to be had in the comic book business inking art penciled by others. We begin with the two drawings on this page, which are excellent examples of the chiaroscuro technique, followed by master artworks shown in both final pencil and pen stages (pages 124–129). You can make your own ink renderings of these artworks by tracing the pencil drawings and inking them yourself.

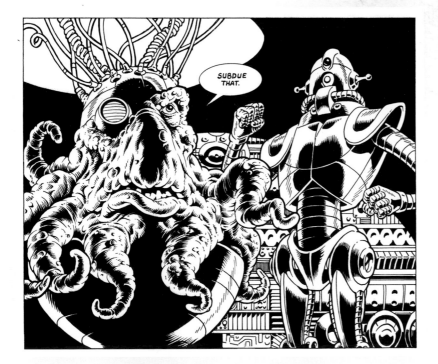

Chiaroscuro (pronounced kjaros-ku-ro) means *light and dark*. An excellent way to add both believability and drama to your inked art is to incorporate the chiaroscuro style. In this style, you focus on the distribution of light and shadow and the use of deep variations in, and subtle gradations of, light and shade, especially to enhance the delineation of form in a dramatic way. Some think of chiaroscuro as being as much (or more) shadow as light. While that is a pretty simplified concept, it is fairly accurate, and while the work can be very high contrast, you can also play with softer tones within chiaroscuro. The drawing above is by Angelo Torres and the drawing at left is by Pat Binder and J. David Spurlock.

This is it! Actually, It, the subject of Theodore Sturgeon's famed short story *It!* The late science fiction author may be best known for his many anthologies, writing for the *Star Trek* TV show (he coined the phrase "Live long and prosper," among others), and his novella *Killdozer!* Originally published in the British edition of *Unknown* magazine (August 1940), the *It!* novella may very well be the world's first swamp or muck monster—predating Marvel's *Man-Thing* (May 1971), DC's *Swamp Thing* (July 1971) and even Hillman's *The Heap* (December 1942). In these illustrations (below and opposite) we see Jim Steranko take the muck monster on—artistically speaking—for *It!*'s cover appearance on Marvel's *Supernatural Thrillers* #1 (December 1972).

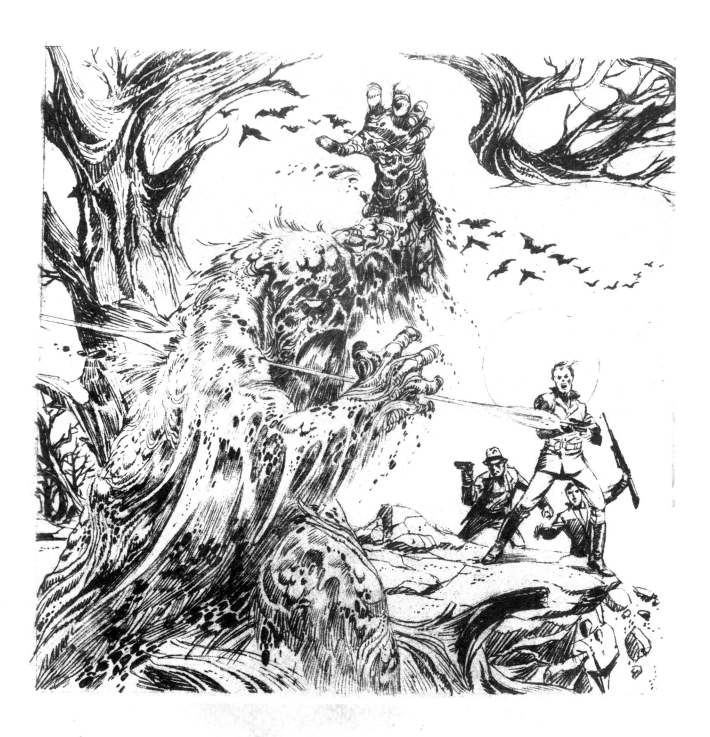

This is a great inked drawing by Steranko. The composition perfectly leads the eye in a figure-6 downward swirl from the tree, through the muck monster, to the hunters, then back to the muck monster, via the gun blast. Note how tightly Steranko rendered the pencil drawing (opposite page), as if he were doing it to be inked by another artist (which is often the case with larger comic book publishers). But many artists, knowing they would be inking their own pencil work, wouldn't often bother to so fully render the details of the muck monster and the tree in the pencil stage.

Note where Steranko kept to or varied from the pencil with the inked version and how, between the monster, tree, and rocks, one brush can produce such a rich variety of textures.

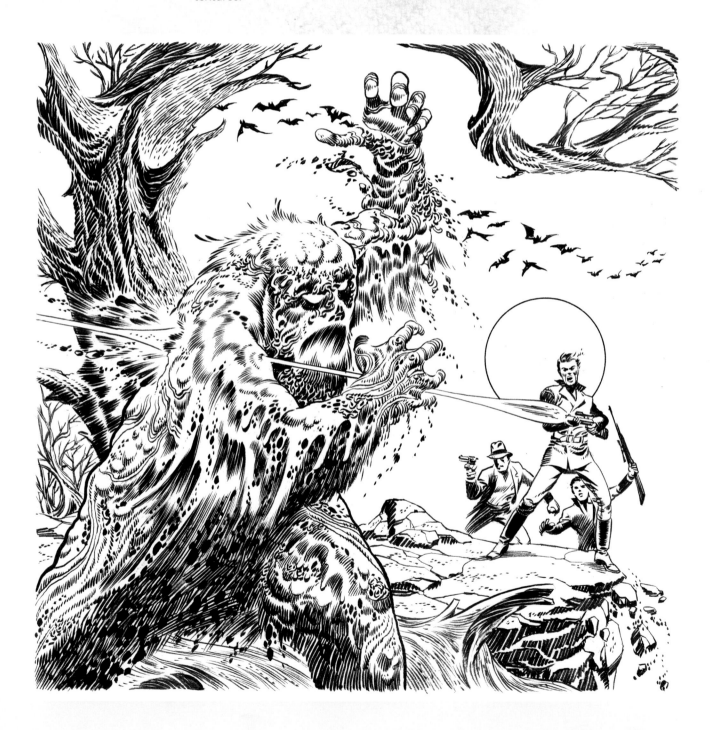

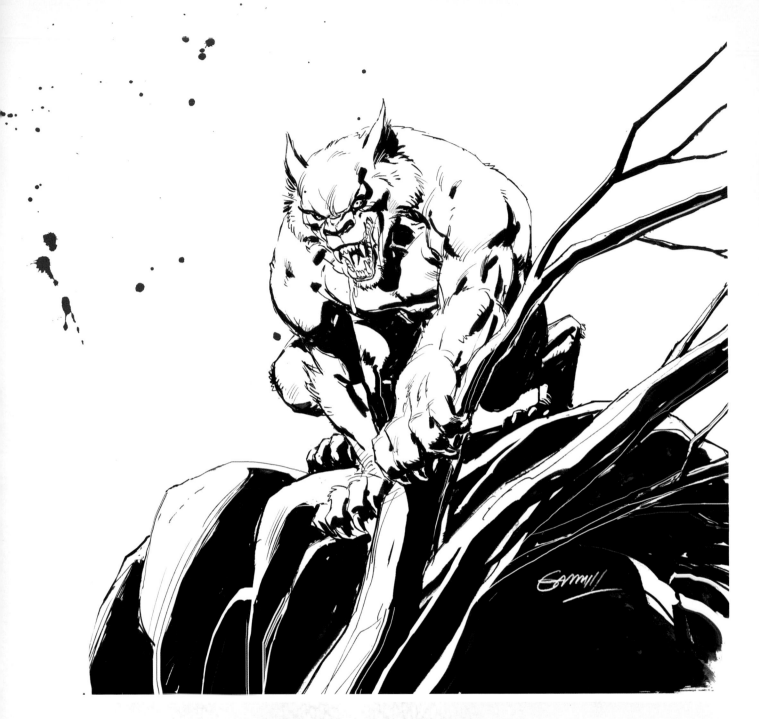

A friendly neighborhood pooch? Not! This werewolf would just love to have you for a snack. Just in case I didn't mention it before, when you go out looking for monsters to draw, you are taking your life into your own hands. Don't say I didn't warn you. Monster maven Kerry Gammill was able to draw this beastie without getting his head ripped off. The finer lines are pen, the broader strokes/shadows are brush, and there looks to be a touch or two of fine-line whiteout work as well.

Note how the shadows are consistent to one primary light source and just a hint of reflected light, say, on the underside of the tree branches. This is the proper way to do it. The slight reflected light adds dimension to the subjects.

The high contrast adds drama. The heavy shadows and moonlit areas indicate that the scene is at night.

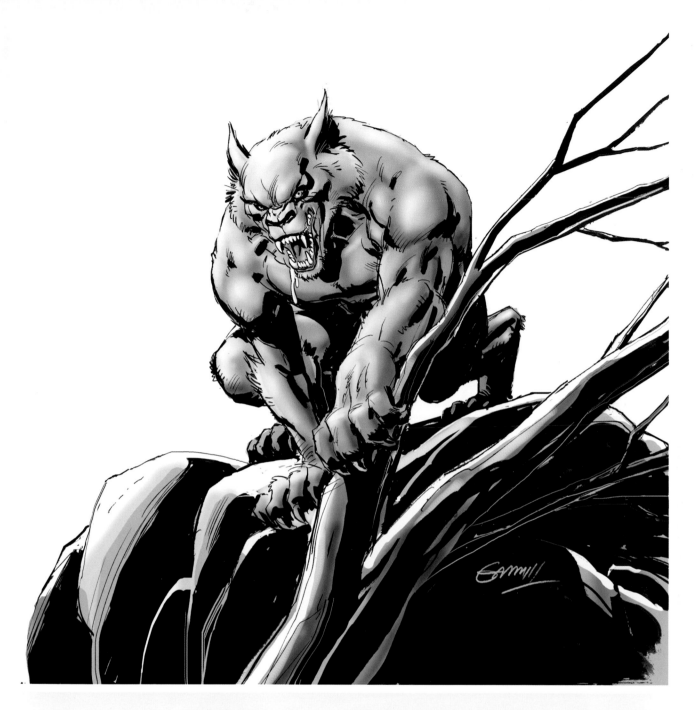

In this updated version, the artist has added tonality. This can be done with dry media such as pencil, pastel, or charcoal or with ink wash or markers—or, as it was done here, with a computer. Scan the ink art into the computer and add tones using Photoshop.

The tones add a richness and atmosphere that are hard to accomplish otherwise. In years gone by, it would cost more to print tone than to print strictly line art, but with the advent of digital graphics, it costs no more, and in some ways it is actually easier now to reproduce tonal drawings than line-art drawings, as they require higher resolution and better-quality scans.

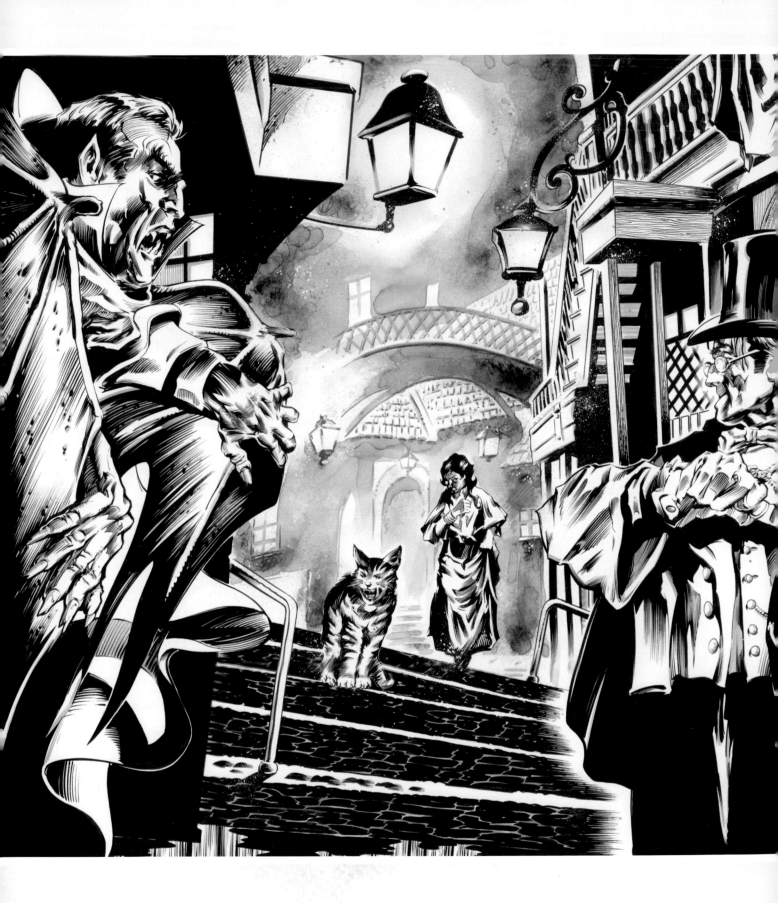

HARD-LINING IT

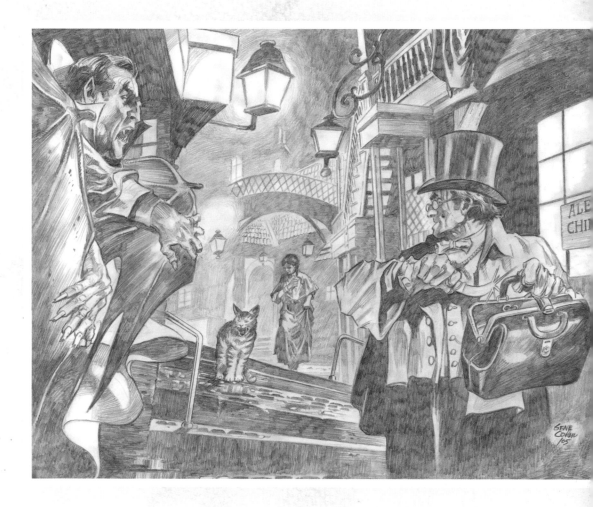

Gene Colan, in the fine art tradition, pencils with his own work in mind and very much appreciates the tonal qualities that pencil affords. He seldom concerns himself with how it will be converted to line art by an inker or reproduced by a publisher. This can create unique challenges for an inker working over Gene's pencils. Publishers have found it takes a superior inker—artists in their own right—to do it just right, and a few who have risen to the top in collaboration with Gene are Tom Palmer, Al Williamson, Klaus Janson, and Steve Mitchell. Likewise, Dave Gutierrez of Abstract Reality Studios has made a specialty of inking Gene Colan's work. Here we see a piece, *Shared Prey*, featuring Dracula and Jack the Ripper by Colan and Gutierrez.

Gutierrez chose to keep the more subtle tones by using an ink wash (ink mixed with water). There are other effects here, including white splatter. All work in harmony to great effect.

BERNIE WRIGHTSON

THE MASTER OF THE MACABRE

Bernie Wrightson, originally from Baltimore, learned his craft from studying EC horror comics like *Tales from the Crypt* and the EC artists, including "Ghastly" Graham Ingels and Frank Frazetta. He also took the correspondence course from the Famous Artists School before relocating to New York around 1968. He quickly gained notoriety in fanzines and at DC Comics with *House of Mystery*, *Nightmaster*, and his hugely successful *Swamp Thing*. *Swamp Thing* was Wrightson's co-creation with writer Len Wein and editor Joe Orlando, who had first gained fame doing art for EC. Though there are muck monsters predating *Swamp Thing*, including in *The Heap* and Theodore Sturgeon's *It!*, as well as Marvel Comics' simultaneous creation, Man-Thing, Swamp Thing remains the most popular and famous muck monster to date. In the early 1970s, Wrightson moved on from DC and *Swamp Thing* to the horror magazines *Creepy* and *Eerie*. Inspired by early fantasy art favorite Roy G. Krenkel and classic illustrator Franklin Booth, Wrightson developed the elaborate line-art style we see in the images in this book, including the doctor and his creature from *Eerie* #68 (Warren Publishing, 1975).

The high point of this most-detailed style of Wrightson's culminated with approximately fifty pen-and-ink illustrations to accompany an edition of *Mary Shelley's Frankenstein*. Wrightson spent years working on these masterpieces. The Wrightson-illustrated edition is an absolute horror classic and has been printed many times. It is currently available from Dark Horse Books.

Wrightson is a favorite of author Stephen King and illustrated the comic book adaptation of the Stephen King film *Creepshow*. He produced illustrations for the novella *Cycle of the Werewolf*; the restored edition of King's apocalyptic horror epic, *The Stand*; and *Wolves of the Calla*, the fifth installment of King's *Dark Tower* series.

Bernie Wrightson, photo © 2006 by David Armstrong

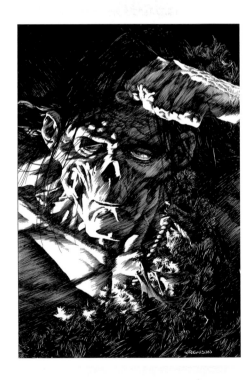

The current (Halloween 2008) Dark Horse Books edition of the classic Bernie Wrightson–illustrated version of *Mary Shelley's Frankenstein*.

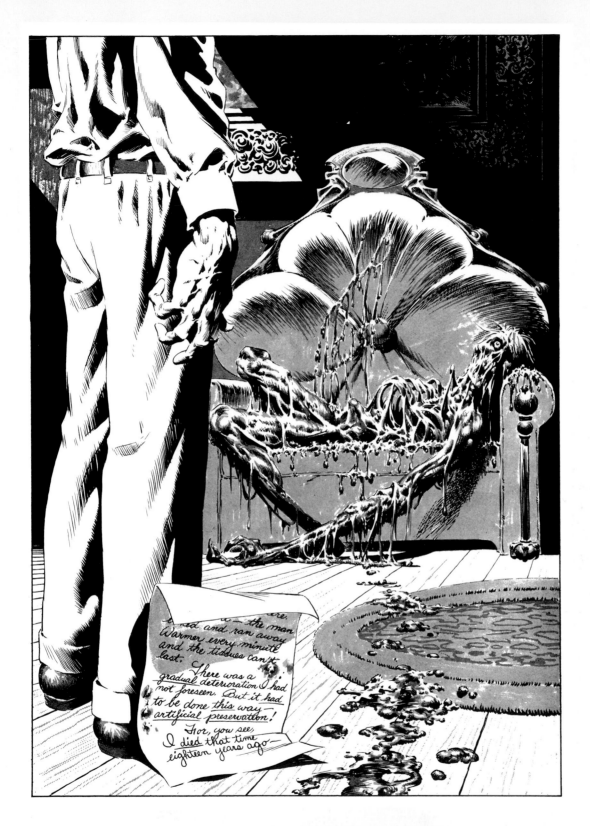

The final scene from Bernie Wrightson's adaptation of H. P. Lovecraft's "Cool Air" from *Eerie* #62 (Warren, 1975). Melted, liquefied flesh—somehow Bernie Wrightson's masterful brush, pen, and ink work make even this, in some ways, beautiful. After laying out the drawing with pencil, the artist inked with pen and brush. The gray shading is Craftint/Duo-Shade.

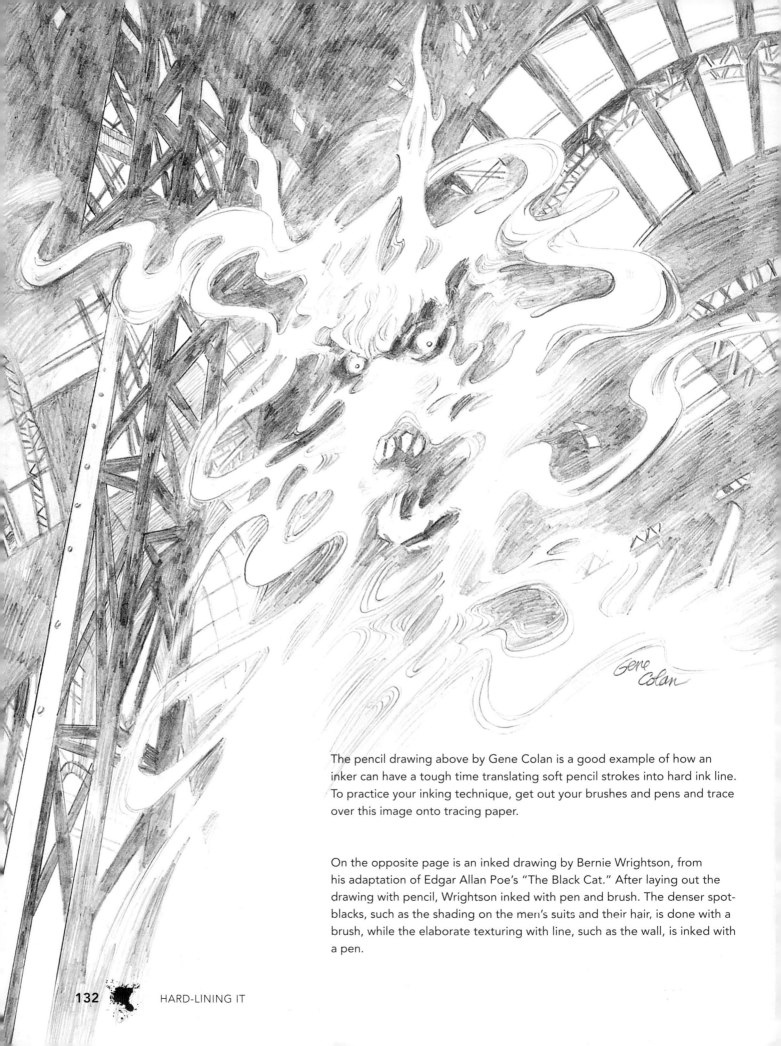

The pencil drawing above by Gene Colan is a good example of how an inker can have a tough time translating soft pencil strokes into hard ink line. To practice your inking technique, get out your brushes and pens and trace over this image onto tracing paper.

On the opposite page is an inked drawing by Bernie Wrightson, from his adaptation of Edgar Allan Poe's "The Black Cat." After laying out the drawing with pencil, Wrightson inked with pen and brush. The denser spot-blacks, such as the shading on the men's suits and their hair, is done with a brush, while the elaborate texturing with line, such as the wall, is inked with a pen.

So, there you have it. We have gone from children's building blocks to expert use of form and structure; from human figures vs. inhuman figures, monsters in your face, monstrous perspective, and foreshortening to chasing after and running from zombies—the walking dead—to piecing together lifeless appendages with Dr. Frankenstein, to mathematical formulas of good composition and design, to hard-lining and inking to ghoulish effect—a chiller journey to remember, and with such company!

We've gone from pop art to fine art via the very finest monster artists ever, and you are still safely in custody of both your jugular vein and your blood supply!

It was a pleasure serving as your tour guide on this expedition, and I hope we can do it again, before the zombie apocalypse, that is.

Pleasant nightmares,
J. David Spurlock

PS: Turn the page for a special bonus: Steranko on storyboards for film and TV, with an introduction by me.

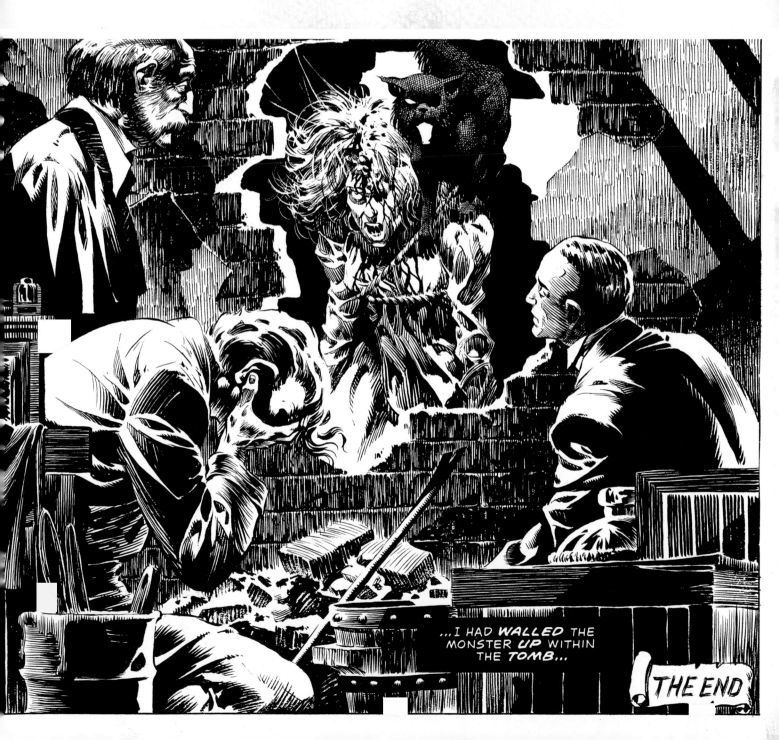

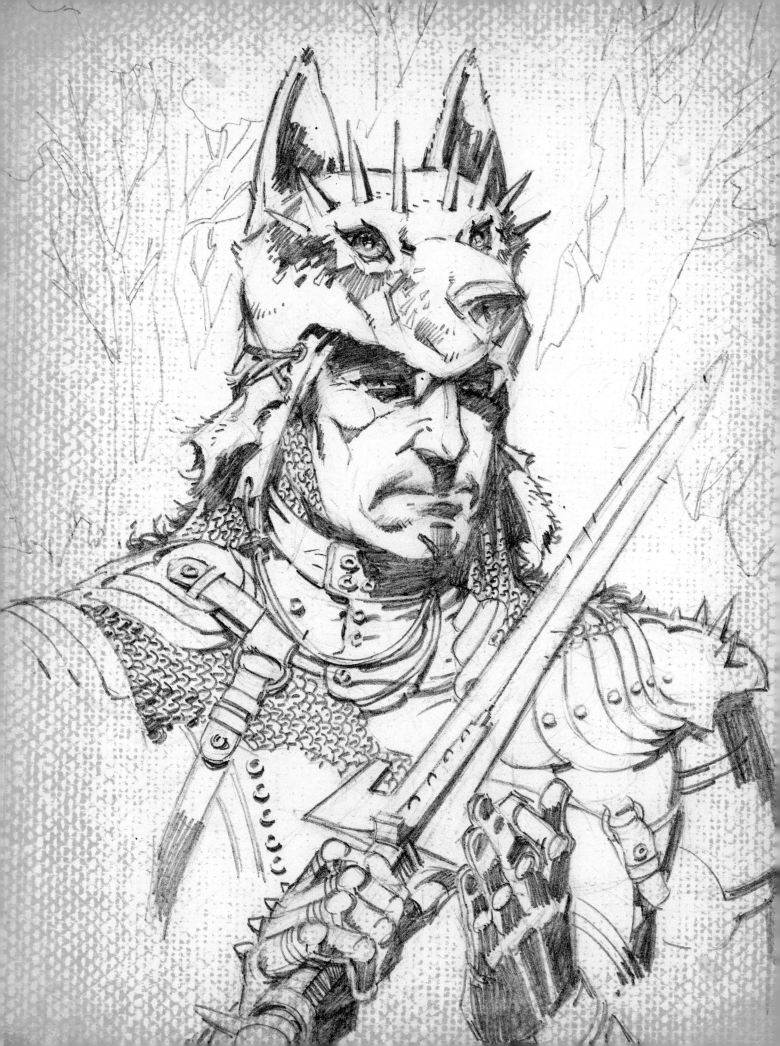

STORYBOARDS
Pre-Direction for Film and TV

The night is darkening round me,
The wild winds coldly blow;
But a tyrant spell has bound me,
And I cannot, cannot go.

The giant trees are bending
Their bare boughs weighed with snow;
The storm is fast descending,
And yet I cannot go.

Clouds beyond clouds above me,
Wastes beyond wastes below;
But nothing drear can move me:
I will not, cannot go.

—EMILY BRONTË
"The Night Is Darkening Around Me," 1837

An innovative take by Steranko on Dracula as a warrior for the Francis Ford Coppola film *Bram Stoker's Dracula*.

Storytelling! Sometimes a drawing or two or three just won't do. Sometimes drawing monsters falls into the area of sequential art. Dating back to morose mummification techniques, diabolically delineated with particular panache as hieroglyphics on ancient Egyptian walls, monstrous sequential art is now most frequently found as comics magazines like *Tales from the Crypt*, *Creepy*, and *Where Monsters Dwell*—and, as storyboards for film and TV. Storyboards are sketches—not meant for publication—usually produced either for pitching or planning TV commercials or helping a film director envision scenes prior to shooting. In the following pages, Jim Steranko reveals some of his work with Francis Ford Coppola on the modern classic (late 1992) *Bram Stoker's Dracula*, which starred Gary Oldman, Winona Ryder, Anthony Hopkins, and Keanu Reeves.

STERANKO'S STORYBOARDS FOR *BRAM STOKER'S DRACULA*

154-1

Billed as Project Conceptualist, Steranko was the third team member hired on the film in March 1991. Coppola was looking for new dramatic and visual ideas, and Steranko (whose film credits include working with Lucas and Spielberg on *Raiders of the Lost Ark*) met his expectation, delivering an avalanche of memos, sketches, inspirations, and storyboards, such as visualizing a Warrior Dracula in a wolf's-head helmet with protruding spikes across the brow line like a crown of thorns (a Christ metaphor); surreal dream sequences designed to lens in 3-D; a Bauhaus castle/fortress with interior construction of alabaster, white Italian marble, stainless steel, and glass—in deco style with Cubist paintings and sculpture; a collection of death masks and erotic photographs enlarged to more than life size; Dracula's tower sleeping chamber, with an onyx floor and a clockwork crypt that automatically rises from it after sundown (he sleeps nude in a padded black patent leather niche carved to the outline of his body); a playful lesbian scene between Mina and Lucy; replacing Carfax Abbey with a deserted slaughterhouse; an underground crypt with a hundred rotting coffins; a masquerade ball staged at London's Crystal Palace with Egyptian decor, jugglers, magicians, fire eaters, and costumed revelers with exotic animals—including Bram Stoker as a reporter and a climax that reveals Dracula's origin in the bowels of Hell!

154-2

154-3

154-4

MEMO

TO: FRANCIS FORD COPPOLA
FROM: JIM STERANKO

Why not target Dracula for radical storytelling
techniques? Audiences who make films into hits are
generally MTVphiles. Why not give them the kind of
pace and style they know best by creating new rules,
transitions, and visuals devices?

Quick idea: When a key scene reaches its climax,
the image freeze-frames and turns sepia. A red line
traces around the perimeter of the central subject
(such as Dracula's figure). As the line is com-
pleted, the entire image splits apart, moves off-
screen in different directions, and reveals the next
scene underneath (see enclosed storyboards).

Will you do Dracula straight or make it a monu-
ment of experimental style?

154-5

 STORYBOARDS

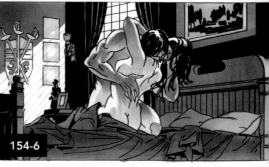

154-6

SCENE 154: DRACULA AND MINA IN SEWARD'S QUARTERS—NIGHT.

(Not drawn to develop characters, costumes, set design, or lighting, only the position of the characters and their size within the frame.) The storyboards begin after Renfield's death. I believe both characters should be nude up to 154-20, when Dracula appears dressed. However, so you can see how he looks with clothes on, I've dressed him from 154-8 onward.

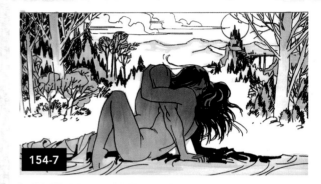
154-7

154-1 CU of Mina. Shadow moves over her face and body, eventually eclipsing her completely.

154-2 CAMERA PULLS BACK TO WIDER SHOT. A black silhouette moves in to embrace her.
Dracula: This is our destiny. Our love can last all eternity. Wilhelmina—
Mina: Take me away from all this death. I want to be what you are. See what you see—love what you love—

154-3 CAMERA CONTINUES TO PULL BACK. Dracula moves behind her, pulls her nightdress off her shoulders, and begins kissing her neck.
Dracula: Then I give you life eternal. Everlasting love. The power of the storm. And the beasts of the earth. Walk with me—be my loving wife forever.
Mina: Yes—I will—Yes—I will.

154-4 CAMERA CONTINUES TO A WIDER SHOT. Mina props herself on one elbow as she faces Dracula. With a sharp thumbnail, he opens a vein on his chest. Blood flows from the cut.

154-5 MED. SHOT. Mina drinks his blood.

154-6 CAMERA PULLS BACK, SHOWING ROOM'S BACKGROUND AND BEGINS SLOWING CIRCLING THE FIGURES. A trickle of blood appears on Mina's neck and rolls down her neck.

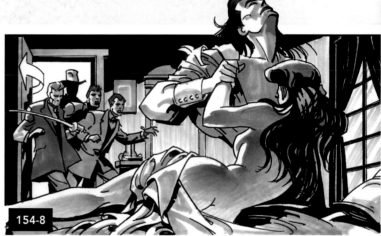
154-8

154-7 The background slowly changes to that of the TRANSYLVANIAN LANDSCAPE (front projection over furniture and walls). As Dracula's passion heightens, all vestiges of the room disappear, and he and Mina seem to be FLOATING AND SWIRLING at an increasingly rapid speed, just feet above the ground (achieved with a process shot). SILHOUETTES of huge, sometimes fallen trees flash by, a vast stretch of evergreens lies behind them, and still farther, the snow-capped peaks of the MOUNTAINS—all bathed in moonlight, Castle Dracula is seen in the background. As his passion grows, the shadows and silhouettes become MIDNIGHT BLUE; lighter tones also take on a blue hue. The scene continues to brighten and flares in a BLUE SCINTILLA that is a metaphor for

Dracula's orgasm. CAMERA STOPS CIRCLING. As the glow subsides, the room comes back into view.

154-8 The vampire hunters suddenly burst through the doorway. CAMERA PULLS FOCUS FROM THE LOVERS TO INTRUDERS.

154-9 CU ON INTRUDERS. They are horrified to see Mina with Dracula.
Holmwood: Mina!—

154-10 MED. SHOT ON DRACULA AND MINA. ZOOM QUICKLY TO CU as Dracula whips around to confront the intruders.

154-11 Dracula momentarily loses control, becoming a hideous CREATURE WITH BLUE IRIDESCENCE emanating from his mouth and nostrils. A deep, hissing GROWL issues from his throat.

154-12 LOW-ANGLE WIDE SHOT FROM BEHIND THE BED. Mina, sobbing, sits up to turn her back in SHAME from the

intruders, who advance toward Dracula.

154-13 CU OF DRACULA. He has regained his composure and reverted to his HUMAN SELF.

Dracula: You're too late! Mina is already mine! Your beloved, is now my flesh, my blood, my kin—my bride! I will fight for her! My armies will rise again—my creatures will do my bidding!

154-14 MED. SHOT OVER DRACULA'S SHOULDER. Holmwood answers by raising a REVOLVER—pausing for a beat, as the audience comprehends the situation.

Holmwood: Soul stealer!

Suddenly, Holmwood fires the gun.

154-15 MED. SHOT ON DRACULA. Impact of bullet slams him against the wall. He slowly drops to the floor. CAMERA POV DROPS WITH HIM.

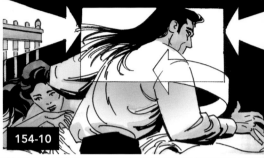

154-16 CONTINUED FROM 15. The intruders' legs enter the frame, casting SHADOWS on the wall. A BULLET HOLE is seen in Dracula's chest.

Mina: (O.S.) (Loud Scream)

154-17 AND -18 CU OF MINA PULLS BACK TO MED. SHOT. Seward and Quincey move behind her from right of frame. Holmwood moves in front of her from right. Van Helsing enters frame from left.

Seward: Mina. Mina. He can't hurt you now. We won't let him.

Mina: It's too late. God help me! I . . . I'm unclean.

Van Helsing: Blasphemy! Be strong, my child. We will help you bear the pain, but there is no easy way to save you from this curse.

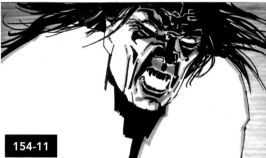

154-19 CAMERA PULLS BACK SLOWLY TO WIDER SHOT. Simultaneously, three things happen: a loud flapping SOUND like the snapping of a bed-sheet in the wind; the SHADOW of a huge pair of bat wings flaps menacingly across the background for a moment; and similar bat wing SHAPES scissor across the frame—then . . .

154-20 SAME POV. Figures part to reveal Dracula EMERGING from the shadows behind them. He is now fully dressed.

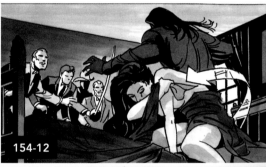

154-21 CU ON DRACULA'S FACE.

Dracula: Shadows do not give up their secrets so easily.

154-22 AND -23 LONG SHOT OVER DRACULA'S SHOULDER. CAMERA MOVES INTO SEWARD, who swings around, pointing the blade in Dracula's direction.

Seward: Man or demon, I'm not afraid of you. Let's see if a shadow can bleed.

154-24, 25 REVERSE ANGLE, MED. SHOT. Seward slashes at Dracula's neck, but before he makes contact, the vampire CATCHES THE BLADE barehanded.

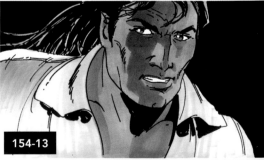

154-26 TIGHT CU of the blade in Dracula's hand. Hold for a beat.

154-27 AND -28 SAME SHOT AS 25. Dracula twists blade from Seward's grasp and rotates the saber to grab the hilt with his right hand.

Dracula: I warn you, leave me—leave us—in peace or join me in the sleep of the damned.

154-29 MED. CU OF QUINCEY revealing a display of swords on the wall behind.

Quincey: (shouts) Seward!

Quincey moves deeper into the frame and pulls a SABER from the display.

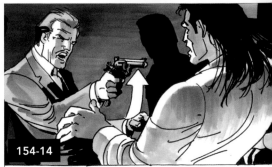

154-30 CAMERA ROTATES TO LEFT as figure gets sword and tosses it off of frame right.

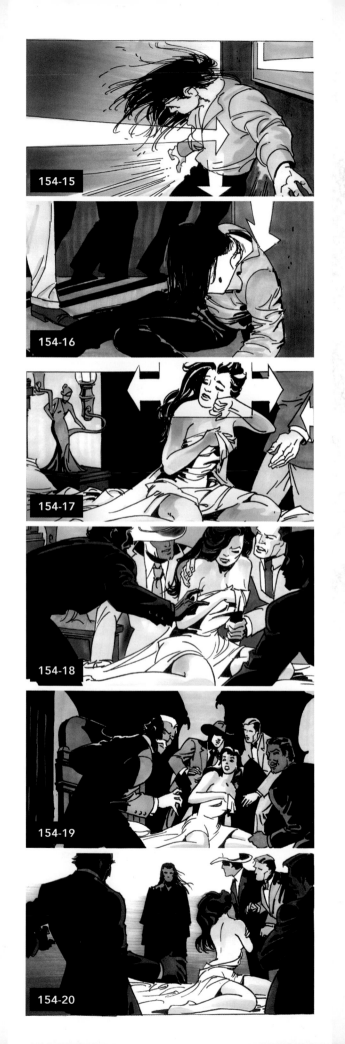

154-15

154-16

154-17

154-18

154-19

154-20

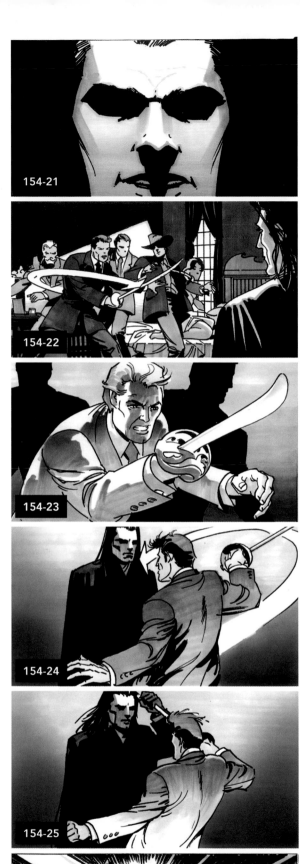

154-21

154-22

154-23

154-24

154-25

154-26

Quincey: (o.s.) Send him back to hell!

154-31 CU POV PANS WITH SWORD RAPIDLY TO RIGHT until a hand reaches up from bottom of frame to catch it.

154-32 MED. SHOT OF SEWARD threatening Dracula with the sword. Mina and Van Helsing are in the background between them.

154-33 MCU OF VAN HELSING AND MINA.

Van Helsing: Take care, Seward! He's had four hundred years to practice.

154-34 REVERSE ANGLE OVER DRACULA'S SHOULDER. Mina and Van Helsing are in the background. The duel begins with Seward initiating the attack.

154-35 MED. SHOT. Seward's attack is extremely VIGOROUS, almost wild. Dracula's swordplay is only DEFENSIVE and almost EFFORTLESS. He is virtually immobile, and all his parries are accomplished with a minimal amount of wristwork, underscoring his consummate DUELING PROWESS.

154-36 MED. SHOT. SAME ANGLE AS 34. Dracula disarms Seward with a circular thrust.

154-37 HIGH ANGLE, WIDE SHOT. At sword point, Dracula drives Seward BACKWARD onto the bed. The vampire hunters close in from various parts of the room. Dracula halts them by raising his left hand.

154-38 MED. SHOT OVER SEWARD'S SHOULDER. Seward is driven farther backward by the point of Dracula's blade.

154-39 POV CONTINUED.

Dracula: (very composed) I understand your anger, my friend, and I admire your courage . . .

Dracula throws the sword off frame. CAMERA PULLS INTO CU.

. . . We are all killers, but not all of us are murderers.

154-40 MED. SHOT OF VAN HELSING AND MINA. The doctor removes a CRUCIFIX from his jacket and thrusts it toward the camera.

Van Helsing: *In manus tuas, domine!*

154-41 MED. SHOT OF CRUCIFIX RISING UPWARD FROM BOTTOM OF FRAME. CAMERA TIGHTENS TO CU.

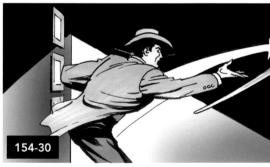

154-42 CU OF DRACULA. CAMERA PULLS INTO ECU. The crucifix's SILHOUETTE EDGES UP Dracula's face until the crossbar eclipses his eyes.

Dracula: You would destroy me with your idols—I who served the cross, who commanded nations hundreds of years before you were born.

CONTINUED FROM SHOT 41. TIGHT CU OF CRUCIFIX.

154-43 CU OF DRACULA with crucifix itself SYMMETRICALLY POSITIONED over his face.

Dracula: *In rega flexus mur!*

154-44 CONTINUED POV FROM 43. Crucifix bursts into flame like a MAGNESIUM FLARE.

154-45 MED. SHOT OF VAN HELSING. The crucifix drops from his hand.

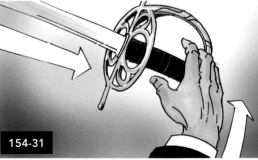

154-46 MED. SHOT OF THE FLOOR BELOW. Crucifix falls into the frame and as if propelled by some supernatural force, shoots out of frame right.

154-47 MED. SHOT OF WINDOW. Crucifix continues its trajectory, SHATTERING the window and disappearing into the night.

154-48 LOW-ANGLE WIDE SHOT. Holmwood crosses from the left side, and the others close in.

Dracula: I could destroy you all—now! But there is no need to prolong our ordeal another moment.

Dracula spreads his arms and bows slightly.

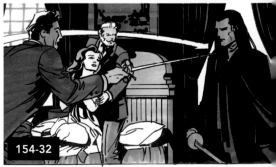

54-33

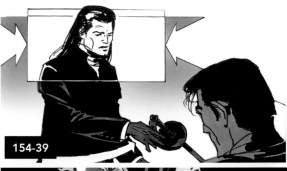

154-39

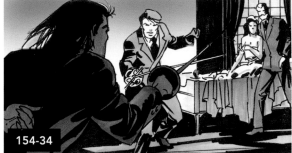

154-34

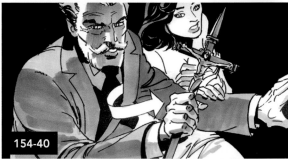

154-40

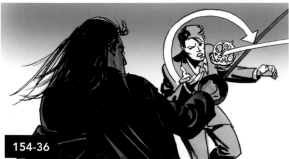

54-35

154-41

154-36

154-42

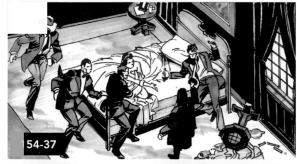

54-37

154-43

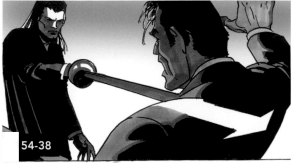

54-38

154-44

154-49 CONTINUED FROM 48. Holmwood crouches down and picks up a fallen saber.

154-50 MED. SHOT OF DRACULA FROM HOLMWOOD'S POV. CAMERA PULLS IN as Dracula spins around, sensing the approach of an ADVERSARY.

154-51 REVERSE ANGLE OVER DRACULA'S SHOULDER. Holmwood slashes his saber downward, as if to CLEAVE DRACULA in two, lengthwise.

154-52 LOW-ANGLE REVERSE. A dark SILHOUETTE OF DRACULA is seen in the middle ground. As the saber slices downward, the silhouette COLLAPSES, the cape flaring out like BAT WINGS and a puff of smoke shoots upward.

154-53 CAMERA CONTINUES DOWNWARD TO THE FLOOR. Dracula's clothes are sprawled on the floor. He has VANISHED. CAMERA MAKES A 180-DEGREE SEMICIRCLE, staying fixed on Holmwood.

154-54 CAMERA MOVES UP to capture the group's surprised reaction.

Holmwood: My God, he's . . . disappeared!

Van Helsing: By the blood of Christ! We've been fools to underestimate his power! He's been trifling with us. Dracula is not bound by the laws of nature. Even the elements are his to command. No, gentlemen, never trust the devil.

Seward moves toward Mina, as does Van Helsing.

154-55 CONTINUED AS CAMERA PULLS UP TO HIGH ANGLE ABOVE THE BED. Seward comforts Mina.

Seward: There's still hope . . . isn't there?

Quincey removes his hat and WIPES HIS BROW with the back of his left hand. He glances at the pile of clothes and moves toward it.

154-56 MED. SHOT OF QUINCEY crouching over Dracula's clothing. CAMERA MOVES IN.

Van Helsing: (o.s.) Damn you, Seward! We'll save Mina if it costs us our lives! You must tell us everything, my child. Hold nothing back, no matter how painful. We must know everything!

154-57 CONTINUED POV. Quincey has been looking back at the bed. Now, he turns and reaches for the pile of clothes—and SUDDENLY flips them over.

154-58 CONTINUED POV. Quincey is jolted by fear when thirty huge, BLACK RATS are revealed hiding beneath the clothes. They SCATTER in every direction, including a half dozen that leap up his arms, toward the camera.

Mina: (o.s.) (screams)

154-59 REVERSE HIGH ANGLE. Quincey shakes the vermin from his arm. The other men try to STOMP on them as the torrent of rats race by, running in all directions across the room and disappearing without a trace into the shadows.

154-60 LOW ANGLE ON QUINCEY. He is still kneeling but is looking back over his shoulder at the group.

Quincey: They're gone! Like smoke in a storm.

Holmwood: (o.s.) Look!

154-61 MED. SHOT OF CRACKED WINDOW. Carfax Abbey is BURNING in the distance. Seward, Holmwood, and Quincey come into the frame.

154-62 MED. CU OF MINA AND VAN HELSING ON THE BED. He is sympathetic to her pain and terror and embraces her with understanding.

Mina: (Sobbing) Unclean . . . unclean . . .

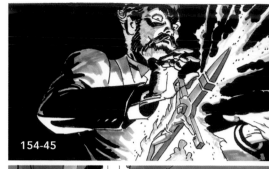

154-45

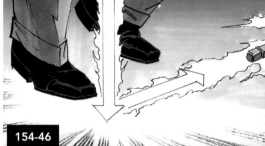

154-46

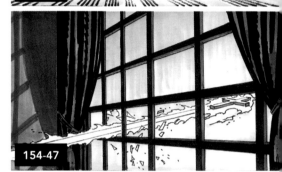

154-47

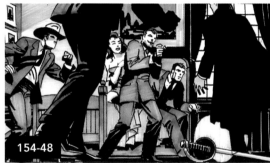

154-48

154-49

154-50

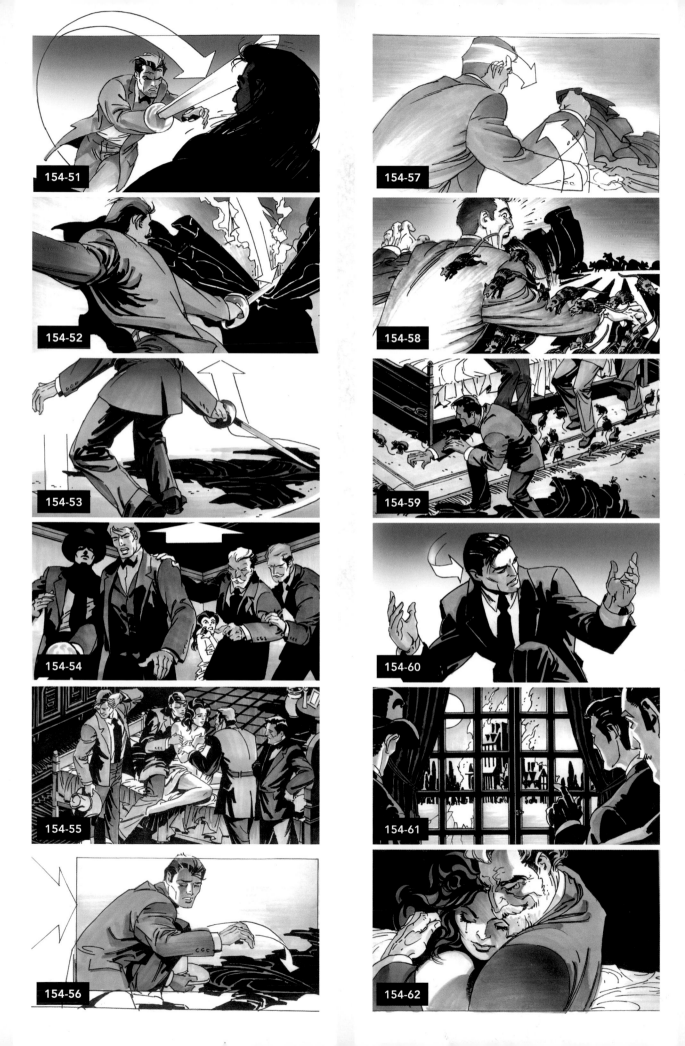

INDEX

Adams, Neal, 53, 73, 105
Adkins, Dan, 41
Balance, 112, 113, 119
Binder, Pat, 96–97, 123
Brushstrokes, basic, 122
Center of interest, 112
Chiaroscuro, 47, 123
Chiaroscuro variation, 119
Colan, Gene, 27, 28–29, 32, 36–37, 66–67, 72, 74–77, 128–129, 132
Color
 aspects of, 112
 compositional relationships, 112
 controlling light and, 40
 goals of, 97
 Jim Steranko on composition and, 114–119
Composition, 111–119
 about: overview of, 111
 center of interest, 112
 components of, 112–113
 essay on color and, 114–119
 examples, 110–111, 113, 115–119
 Golden Mean, geometry and, 113
 Jim Steranko on color and, 114–119
 path of viewer's eye, 112
 relationships, 112
Cropping, 112
Davis, Jack, 90–93
Ditko, Steve, 15, 18–19, 32
Dracula. See Vampires
Figures. See also Heads
 adding tones and texture to, 40. See also Tone and texture
 avoiding "flat" images, 26
 from basic shapes, 13, 14–15
 body size relative to head, 14
 drawing from photographs, 26–27
 lengthening heroic figures, 14
 life drawings, 24–25
 man vs. inhuman, 23
 musculature example, 22–23
 perspective affecting, 25. See also Perspective and foreshortening
 reference materials for, 24
 starting with directional lines, 24
 trap to avoid, 23
Foreshortening. See Perspective and foreshortening
Form and structure. See also Figures; Heads
 about: overview of, 13
 basic shapes and, 13, 14–15
 perspective and. See Perspective and foreshortening
Frazetta, Frank, 44–47, 98, 130
Gammill, Kerry, 9, 30, 33–35, 82–83, 104–109, 113, 126–127
Geometry, compositional, 113
Gogos, Basil, 9, 16–17, 20, 22–24, 38–39, 48–49, 68–69, 70–71, 80–81, 84–89, 104, 110–111
Golden Mean, 113
Gutierrez, Dave, 66–67, 129
Hard-lining, 121–133
 basic pen and brushstrokes, 122
 of Bernie Wrightson, 130–133
 examples, 123–129, 130–133
 inking pencil drawings, 123–129, 131–132

 tools and supplies, 122
Harmony, 112, 116–117, 119
Hartman, David, 10, 21, 54–65, 94–95
Heads, 16–21
 from basic shapes, 16
 basis of shape, 16
 classic proportions, 16
 examples, 16–21
 layers of forms in, 16
 relationship to body size, 14
 varying shapes, 16
High-key variation, 116–117
Horley, Alex, 10–11, 80, 98–103
Inking. See Hard-lining
Janson, Klaus, 129
Kubert, Joe, 24–25, 31, 35
Light and shadow. See also Tone and texture
 controlling light, 40
 lighting defined, 112
 monster examples, 41, 43, 45–47
 reflected light, 22–23, 126
 relationship of, 40
Low-key variation, 119
Mastroserio, Rocke, 93
Monsters (Frankenstein, etc.), 79–93. See also Vampires; Werewolves; Zombies
 about: overview of, 10, 79
 basic-forms structure of, 13, 14. See also Figures
 of Basil Gogos, 84–89. See also Gogos, Basil
 demonstrations, 82–83, 86–89
 examples, 10–11, 12–13, 78–79, 80–83, 85–89, 91–93, 130
 Frankenstein story, 80
 of Jack Davis, 90–93
 light, shadow, tone, texture of. See Light and shadow; Tone and texture
Morrow, Gray, 26
Negative space, 112, 119
Orientation, 112
Palmer, Tom, 129
Path of viewer's eye, 112
Pattern and rhythm, 112. See also Tone and texture
Perspective and foreshortening, 29–37
 about: overview of, 29, 112
 effects of, 29
 figures illustrating, 30–37
 foreshortening and, 29
 guidelines for drawing figures, 30
 human examples, 31, 35
 monster examples, 30–34, 36–37
 reclining nude example, 31
 3-D effects, 31, 32, 34–35
Photographs, drawing from, 26–27
Polychromatic variation, 119
Prismatic variation, 116–117
Proportion
 defined, 112
 of heads, 16
 training mind to draw in, 30
Reflected light, 22–23, 126
Rhythm and pattern, 112
Shadow. See Light and shadow
Shape(s)
 basic, figures from, 13, 14–15

 defined, 112
 of heads, 16
Spotlight Artists
 Alex Horley, 98–103
 Basil Gogos, 84–89
 Bernie Wrightson, 130–133
 David Hartman, 54–65
 Frank Frazetta, 44–47
 Gene Colan, 74–77
 Jack Davis, 90–93
 Jim Steranko, 114–119
 Kerry Gammill, 104–109
Steranko, Jim, 10, 114–119, 124–125, 134–143
Storyboards (for Bram Stoker's Dracula), 135–143
 about: overview of, 135
 project insight and memo, 136
 sequence of, with captions, 137–143
Structure. See Figures; Form and structure; Heads
Texture. See Tone and texture
Tone and texture. See also Light and shadow
 about: overview of, 39
 adding to basic-shape figures, 40
 background texture, 19
 basic pen and brushstrokes, 122
 contrast of, 20
 defined, 40
 inking pencil drawings and, 123–129, 131–132
 monster examples, 38–39, 43, 45–47, 50–51, 64–65, 86–89
 texture exercise, 42
Tools and supplies, 122
Torres, Angelo, 51, 123
Vampires, 67–77
 Bram Stoker's Dracula storyboards, 135–143
 examples, 26–27, 36–37, 66–67, 68–73, 75–77, 113, 128–129, 134–135
 of Gene Colan, 36–37, 66–67, 74–77
 historical perspective, 68
Viewer's eye, path of, 112
Viewpoint, 112
Vokes, Neil, 36, 52–53, 68, 70, 80–81, 110–111
Werewolves, 95–109
 about: overview of, 95
 of Alex Horley, 98–103
 demonstration, 99–103
 demonstration drawing, 99–103
 examples, 38–39, 46–47, 94–95, 96–97, 99–103, 105–109, 113, 126–127
 historical perspective, 96–97
 of Kerry Gammill, 104–109
 layers of forms in, 16–17
 manlike vs. wolf-type, 96–97
Williamson, Al, 43, 44, 53, 129
Wood, Wallace (Wally), 18, 41
Wrightson, Bernie, 78–79, 93, 120–121, 130–133
Zombie, Rob, 8, 54, 84, 98
Zombies, 49–65
 apocalypse, 49
 characteristics of, 51
 David Hartman on, 54–65
 defined, 51
 examples, 21, 48–49, 50–53, 55–65
 origins of, 51